ACTION AND *AGENCY*

ADVANCING THE DIALOGUE ON NATIVE PERFORMANCE ART

NANCY J. BLOMBERG

EDITOR

ACTION AND AGENCY

DENVER ART MUSEUM

DENVER, COLORADO

CONTENTS

FOREWORD & ACKNOWLEDGMENTS

The Native Arts Department of the Denver Art Museum is very pleased to offer the proceedings from our second biennial symposium, held April 4–5, 2008, during which many talented artists and scholars spent two days discussing and witnessing the exciting field of performance art.

We are greatly indebted to the Ford Foundation and Elizabeth Theobald Richards for underwriting both the symposium and the publication of this book. During her tenure at the Ford Foundation, Betsy has been a strong voice for native arts and artists and we can't thank her enough for helping to establish our symposium and residency program.

Additional funding for Floyd Favel's residency and performance of *Snow before the Sun* was provided by an Economic Development Initiative Grant made possible by former U.S. Senator Ben Nighthorse Campbell.

Lara Evans's help in structuring the symposium was crucial to its success. Her advice and experience were instrumental in helping to identify the salient issues in the field of performance art, and her suggestions for key scholars and artists to invite were brilliantly on target.

A huge thank you goes to the staff at the Denver Art Museum for supporting this project at all turns. In the Native Arts Department, associate curator Polly Nordstrand was a major force in Floyd Favel's residency and the symposium that emanated from it. Her interest and enthusiasm for this exciting field pushed the DAM to explore performance art in greater depth. The enclosed DVD of Favel's performance was produced by Polly, with videography by Ava Hamilton, editing by Derek Brown, lighting design by Jane Spencer, and music composition by Leela Gilday.

This project would not have been brought to completion without the expert management skills of curatorial assistant Jennifer Pray. She more than ably managed all of the tedious—but crucial—aspects of

completing this book, from image acquisitions and artists' permissions to research and footnote details, publisher and editor contacts, and proofreading and photo captions. We thank her for her hard work and dedication—not to mention good humor—through all the inevitable crises.

Jeff Wells, our master photographer, provided his expertise in preparing photos for publication. Megan Cooke and Chiara Robinson in DAM's Development Department were responsible for securing the necessary funding for both aspects of the project—thank you. Thanks also to Laura Caruso, who patiently and expertly edited the papers to make a coherent whole.

And finally to all of the authors and artists who took time from their other projects to participate in the symposium and contribute to this volume—many, many thanks!

Nancy J. Blomberg
Curator of Native Arts
Denver Art Museum

7

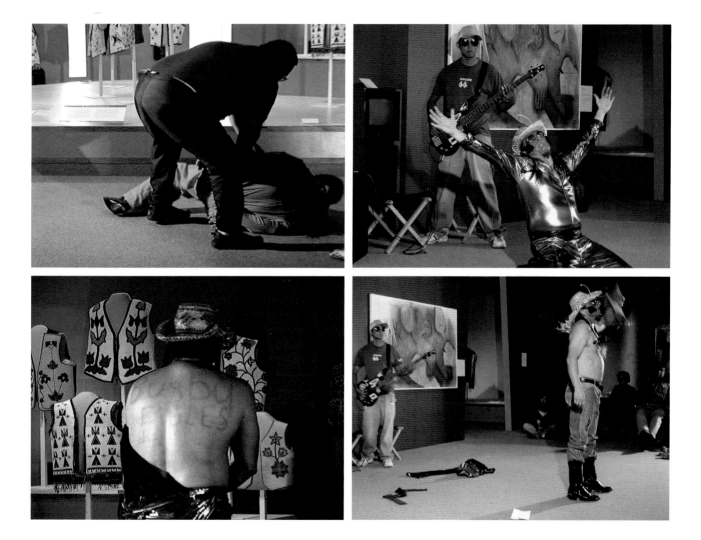

FIG. 1 *TESTIMONY OR . . . YOU CAN'T KEEP A GOOD INDIAN DOWN*, 2003, BENTLY SPANG

PERFORMANCE AT THE DENVER ART MUSEUM, DENVER, CO

SETTING THE STAGE

Nancy J. Blomberg

What is "performance art"? How do we define it? Discuss it? Critique it? Create it? And collect it? Its historical origins are debatable, with scholars suggesting anything from Renaissance times to the Dadaists of the early twentieth century to the turbulent 1960s. Many remind us that most non-Western cultures have long embraced performances in ritual and storytelling as integral to their very existence.

For more than a century the Denver Art Museum has actively engaged audiences with a broad range of art experiences, but our involvement with performance art has been limited. In 2003, as part of our nascent artist-in-residence program, we invited Bently Spang to spend a week with us in our collections and galleries, where he created two performances (FIG. 1). In 2007 Floyd Favel took part in a similar program at the DAM and performed *Snow before the Sun* as discussed in Polly Nordstrand's essay. These inaugural forays into performance art were somewhat limited in scope but well received by our visitors, which prompted us to take a more in-depth look at the greater world of Native American performance art and some of the issues important to its future. Issues such as:

How do native artists use performance to analyze social conditions and offer solutions?

9

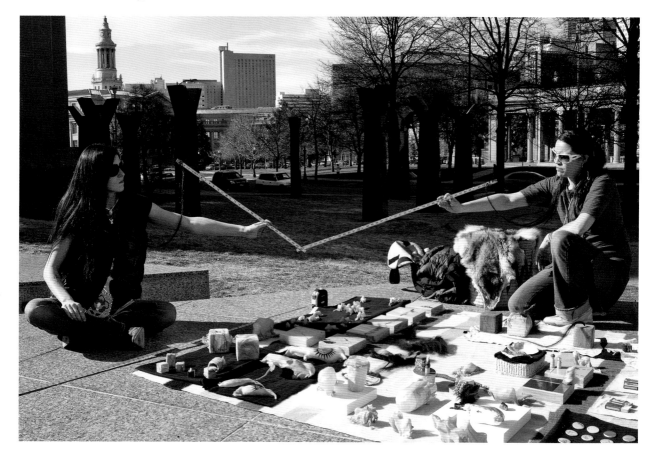

10

How can the artist use performance as a means of transmitting knowledge?

How does the artist build communities among artists—and also between native and non-native populations and individuals?

What is the lifespan of a performance work? Does the camera merely document the moment, or does it create another artwork?

What are the issues for iconic works like James Luna's *The Artifact Piece* and the implications for restaging such works?

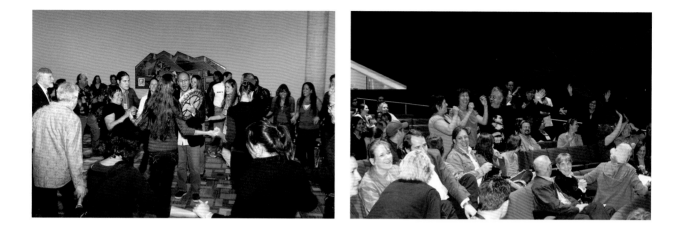

Our internal discussions led to the development of our second biennial symposium examining critical issues in contemporary American Indian art. During April 4–5, 2008, we convened a group of distinguished artists and scholars at the Denver Art Museum to debate and discuss these key issues. The days were filled with thoughtful papers and the discussions that followed were lively and engaging. However, with an auditorium full of performance artists it became much more than the usual format of a series of presenters speaking from a podium. On the first day of the symposium, a Friday, artists Maria Hupfield and Merritt Johnson performed *Museum Quality* in three locations on the public plaza surrounding the museum (FIG. 2). Symposium participants and museum visitors alike engaged with them during their performances. After the final papers of the day were presented, registrants relaxed and interacted in the free-form setting of an evening performance jam (FIG. 3).

On Saturday, during James Luna's much-anticipated performance of *FOUR WAYS,* he encouraged audience participation and engagement. The auditorium came alive with creative energy (FIG. 4).

FIG. 3 **PERFORMANCE JAM**, APRIL 4, 2008

FIG. 4 **AUDIENCE AT FOUR WAYS PERFORMANCE**, APRIL 5, 2008

The papers in this volume represent the majority—but not all—of the participants in the two-day symposium. Lori Blondeau (artist and director of the Canadian arts organization TRIBE) and Candice Hopkins (director and curator at Western Front in Vancouver) were both active contributors to the symposium and added immeasurably to the dialogue, but were unable to participate in the published proceedings.

Rebecca Belmore starts off this volume recounting the startling historical narrative of a Mi'kmaq man who had been taken captive and transported to Europe several hundred years ago. While there, he was instructed to publicly "perform" the role of a deer hunter in an outdoor garden from the actual killing of the animal through to dressing, cooking, and eating it—a performance to which he added an unexpected improvisation. Belmore provides this account of what she considers the first international performance by a native artist and then explains how it formed the basis for one of her own recent performances.

Scholar Marcia Crosby takes a close look at Belmore's large body of work as it thematically references global conditions of war, trauma, violence, and chaos while digging deeper into the layers that consider the acts of specific individuals and events with their own histories. In her essay she analyzes the powerful performances created over Belmore's twenty-year career, exploring the intersections with both national and international events.

Tackling the topic of performance art as a means for transmitting knowledge, Polly Nordstrand's paper examines one specific performance by Floyd Favel titled *Snow before the Sun*. Performed at the Denver Art Museum in March 2007 at the end of a week-long residency, *Snow before the Sun* was an original performance piece inspired by two iconic cultural references: the infamous historical photograph of Chief Big Foot's frozen body at Wounded Knee in 1890 and the 1970s cult film *Billy Jack*. Nordstrand helps us understand how Favel melded the heroism of two

historical and fictional characters to create a powerful narrative performance. (The complete performance is included on a DVD in the back of this book.)

James Luna first performed his seminal work *The Artifact Piece* more than twenty years ago. Luna used the aesthetics of museum display practices to question assumptions about object/subject and continuity and authenticity. In 2008, artist Erica Lord reenacted Luna's piece at the National Museum of the American Indian in New York City. Lara Evans's paper describes and compares both performances and analyzes their impact on museum audiences today and on the future of the field of performance art studies.

On the final afternoon of the symposium, Luna performed *FOUR WAYS* before a full auditorium at the Denver Art Museum. For nearly an hour he held the audience spellbound throughout a narrative that alternately combined humor, irony, ceremony, and painful memory—all punctuated with live music and dance. In a rare glimpse inside the process of developing and producing a major performance, Luna takes us methodically through his personal creative process, the multiple acts that comprise the performance of *FOUR WAYS,* and his ambitious plans for future writing and directing.

Tina Majkowski positions herself as a "critical fan" of Kent Monkman's work. In her essay she carefully considers the depth of his multifaceted career as painter, filmmaker, and performance artist and how his body of work approaches issues of indigeneity, nationalism, and "queerness." Majkowski uses Monkman's often-in-your-face art to examine the relationship between indigenous art practice, native representation, and native performance.

Performance art is often ephemeral and seldom documented. But if performances are not recorded, how will future scholars reference them and how will artists build on past work if it is not documented, archived,

and then made accessible? Should museums preserve these works of art and add them to their permanent holdings, and if so, how? Greg Hill is both a museum curator and performance artist, and his thoughtful essay discusses the camera in relation to his own work and some of the things that happen when the camera is involved in his performances. He asks the salient question of whether the camera is merely an unobtrusive documentary tool or whether it changes the nature of the performance itself. Also, if the performance has a contemporary political component, and media crews are present, what effect does their presence have on the performance and its documentation?

The final essay, by professor Tavia Nyong'o, takes a broader look at the field of performance art and specifically at the intersections and differences between issues in Native American performance—cultural survival, treaty rights, and sovereignty—and those of the African diaspora. He posits that both use as a starting point an archive or historical repository of knowledge, as defined by Michel Foucault and discussed at length by Nyong'o. But rather than accepting the limits of the archive, Nyong'o thoughtfully suggests that indigenous performance artists rethink these limits and expand upon them to create more complex and powerful narratives for future performances.

As an extraordinary form of artistic expression, performance art is now well recognized and accepted. Uncountable participants create thought-provoking performances that both challenge long-held misrepresentations of native people and celebrate complex cultural histories. Formal training programs have been established in this critical field of study at art schools and universities. But it is still a relatively young field, with limitless opportunities for growth. The stage is large and the players are brilliant. Let's keep the action rolling.

MAKING A GARDEN OUT OF A WILDERNESS

Rebecca Belmore

In 1997 I was hired as facilitator at the Banff Centre in Banff, Alberta, for an artist's residency, the theme of which was "Apocalypso."

One of my duties was to give a lecture on performance art. I am not an academic, so the podium is not my chosen platform. The weekend prior to the lecture, still thinking about my task, I visited a close friend in Lethbridge, Alberta, who had married an anthropologist. They gave me their office/spare bedroom, which had a wall lined with books. That night I went to sleep with a small chapbook titled *1492 and All That: Making a Garden out of a Wilderness,* by Ramsay Cook. It cited the writing of a Baptist missionary who recorded a story as told to him by the Mi'kmaq people. This is what I remember of it.

One of them, a Mi'kmaq man, was taken to France where he was placed in a wilderness garden with a deer. There, he was told he was to perform for an audience of nobility: he was expected to kill the deer with a bow and arrow, skin and dress the carcass, then cook and eat it. According to the Mi'kmaq, wrote the missionary, the man adhered to their instructions but took the liberty of expanding on their idea of his performance by "easing himself before them all." I took this to mean that he shat upon the ground. I thought about the site where I was about to give a lecture on my discipline as a performance artist.

The Banff Centre is located in a small town called Banff; both are contained within the boundaries of the Banff National Park, which was created to protect what remains of the "Canadian wilderness." I knew what to do. I saw myself as him—the Mi'kmaq man trapped in a "wild" garden.

A day before my scheduled lecture, I took a shit in the bushes behind the building that housed my studio. After that, working with a couple of Mohawk media artists, I arranged to capture two different video images of myself: one in which I used a gasoline-powered leaf blower to clear a path through the forest, and another I am in this forest running swiftly, head slightly down, hands tied behind my back, and then falling, kicking, digging, barefoot into the earth (FIG. 5).

I go to a place behind my studio on the day of my lecture to collect my shit and put it in a large jar. I also collect elk shit and put it in an identical jar. (Elk roam freely through this world-famous town. You have to be careful not to get too close to them; they may seem tame but are still wild.) I place each jar into a plain brown paper bag. The lecture begins. I arrive carrying the two bags. I stand at the lectern while the "leaf blowing machine imagery" is projected onto a screen. When it is finished, I take the jars out of the paper bags and describe to the audience what I had read in the chapbook. At this point, I leave the room with my fecal specimens and go down the hall to the women's washroom where I empty the jars of our shit into the toilet and flush. I return to the room to finish the lecture by projecting the imagery of me running with the hands bound, an escaped captive Indian.

I consider this Mi'kmaq man to be one of the first performance artists of the Americas to work internationally—hundreds of years ago.

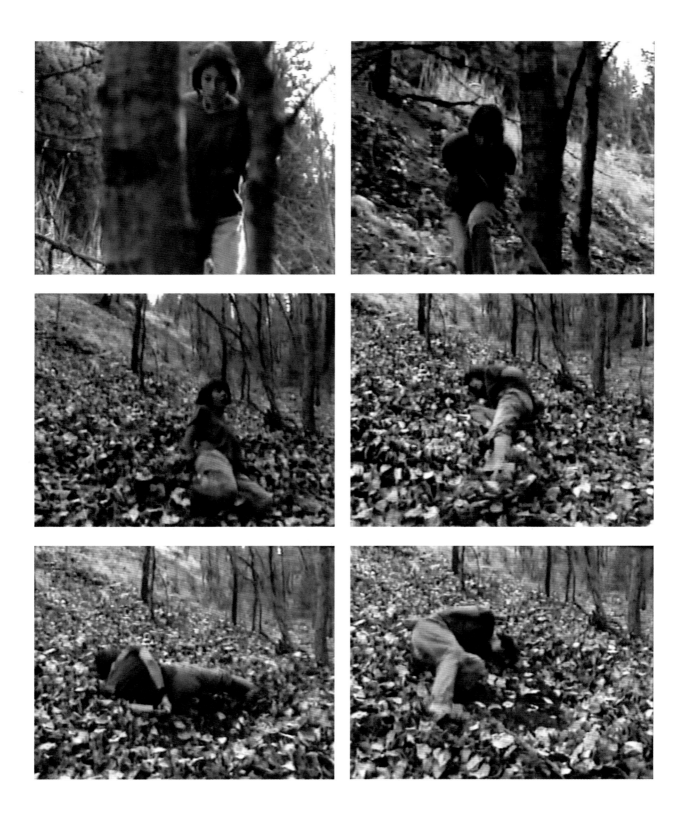

FIG. 5 **IN A WILDERNESS GARDEN**, 1997, REBECCA BELMORE

PERFORMANCE AT THE BANFF CENTRE, BANFF, AB

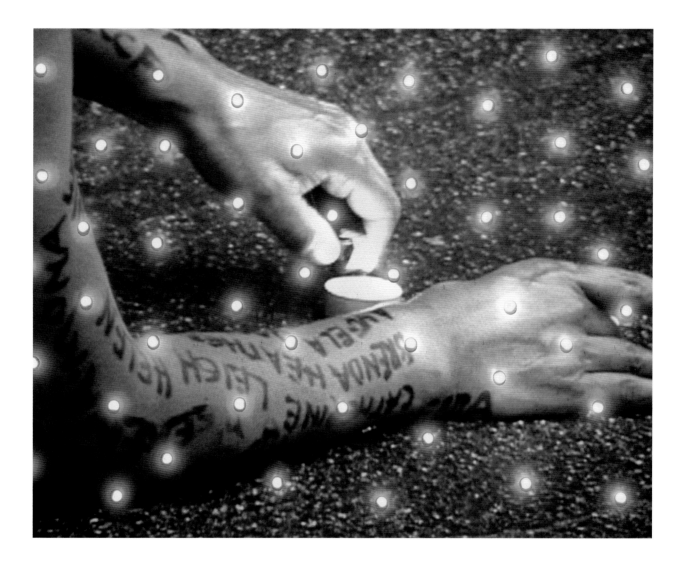

FIG. 6 *THE NAMED AND THE UNNAMED*, 2002, REBECCA BELMORE

VIDEO INSTALLATION

THE MULTIMEDIA WORK OF REBECCA BELMORE
A DISTURBING UNCERTAINTY

Marcia Crosby

Many of the works of Canadian multimedia artist Rebecca Belmore include disturbing representations of violence, which on one level are about the particular and are layered with encoded references to very specific individuals, acts, events, peoples, and spatially bounded locales.[1] Each of the empirical referents for these artworks has its own deep histories, embedded as they are in larger histories of cultural trauma, most of which have been obscured from public view. In performance, installation, photography, and video, Belmore refers to power imbalances between the state and individuals, between groups of peoples, or between individuals. References to, or representations of, violent subject matter are evident in works such as *Creation or Death: We Will Win* (1991), *Bury My Heart* (2000), and *March 5, 1819* (video installation, 2008). Other works refer more specifically in time and place to local trauma and violence, such as *A Blanket for Sarah* (1994), *For Dudley* (1997), *Vigil* (2002), *Crimes of Passion in Paradise and Beyond* (Trinidad, 2002), *Walk of the Righteous* (2003), *Freeze* (2006), *White Thread* (2003), and *Making Always War* (2008).[2] During the span of her twenty-year career, Belmore has turned consistently to performance art after being initially inspired by the Cuban-American artist Ana Mendieta (1948–1985), who explored the theme of violence against female bodies in various media from "earth-body" sculptures to photography, video, and performance art.

Trauma in aboriginal performance art can be linked to the performative dimensions of social and political "action art," ritualized action, cleansing, mortification, and marking the body with various kinds of "wounds" (which is the literal translation of the Greek word "trauma"). The term has been used more recently in the study of post-traumatic stress disorder (PTSD) to refer to a single event (sudden injury, death,

natural disaster) or a prolonged injury caused by abuse over time, such as, I would say, colonialism.[3] As an art strategy, woundings have been used to address violence in the artists' political and social worlds.[4] Such actions make language for past and present trauma, and they can shock and unsettle (create uncertainty), reactivating old traumas that may be reinscribed in the body of the performer and/or audience. For example, some performances may trigger responses such as falling back in unconscious time, in which the person assumes the position of a learned "seething state of watchfulness" ("autonomic hyper-arousal") with its associated self-protective state of quiet immobility.[5] In this condition, old images filter in "wordless and static . . . [like] a series of still snapshots or a silent movie," as Judith Herman describes in *Trauma and Recovery*.[6] Even just writing about such performances may activate a process of both acting out and "working through" an experience of personal trauma.

Defined broadly, performance is an art form that "happens at a particular time in a particular place where the artist engages in some sort of activity, usually before an audience . . . [and] is distinctly different than other modes of visual art practice in that it is a temporal event or action."[7] Historically, performance art as a medium, especially street performance, has been a particular form of resistance which did not/ does not lend itself to conventional containment within museums and did not easily enter the museum or the realm of art magazines.[8]

In relation to performances that reference specific historical events, it's important to bear in mind that the ephemeral nature of performance art (in general) does not lend itself to "telling" specific historical narratives or producing meaning or explanations; having said that, performance *can* disentangle histories in very particular ways. That is, an artist at one level may refer to personal, local, cultural, or national narratives of prolonged abuse or trauma (as fiction or empirical fact); and the body, its gestures (and other media) may expose the imbalance of power relations of a personal trauma. In an aboriginal performance that

is focused on trauma or violence, performer or spectator may gather any number of the narrative strings of colonialization: lateral violence in the home or community, the dissolution of family, residential schooling, decimating diseases, diaspora, the emergence of fluid or unstable urban aboriginal communities—any events and/or conditions that make up the complexity of colonialism's historical and ongoing woundings. That said, such narratives are a referent or perhaps only "one arrangement" of an oscillating constellation of other possible elements to the performance, which raise questions about power itself. The performance "breaks up at the very levels of comprehensibility and acceptance . . . The situation of oscillation becomes even more problematic when it is a question of being there, in action, in front of a certain number of witnesses, of presences."[9]

Given the contingencies of performance art, Belmore does not use the form as an attempt to make meaning or create closure in relation to the specific historic events she references. She is well aware that in its capacity to elicit both a somatic response and to call up specific memories, the language of performance art is transient, it is gesture, trace remains of anecdotal evidence; it cannot be objectified and can hardly be explained, and it is viscous in its contradictions. The duration of a work draws a *momentary* horizon line, pointing both to what is known and that which is emergent and thus yet incoherent. (But even what is "known" in her work in terms of subject matter and possible referent is conflicted, given the proximity between populist and state-produced ideas about the "other.") Belmore's repetitious use of images of violence, which are also held in tension with images of beauty, constitutes a strategy that adds to the disturbing or unsettling nature of the work— new meanings continually emerge, calling into question contemporary norms, images, sounds, words, gestures.

Themes of violence and the ephemeral nature of performance itself conspire to create *uncertainty* (i.e., to disturb, shock, or unsettle), all of

which resonates with the theories and methodologies employed by anthropologists and writers Michael Taussig and Arjun Appadurai. They, like Belmore, point to the relationship between uncertainty and violence and to the ways in which uncertainty constitutes (to some degree) one of the preconditions for violence. Both writers discuss and describe violence in the form of physical brutalities and indignities to the body (citing and describing in detail beheadings, rapes, various modes of torture, and other violent acts) as related to specific events, peoples, and geographic spaces. Each describes violence as it is linked to issues of representation in mass media and to power imbalances in various socioeconomic and political arenas. Taussig's book *The Nervous System* is partly informed by his experience in the more subtle violence of institutional practice in American universities and in the violence of Colombia in the 1980s.[10] Appadurai's 1998 essay, "Dead Certainty: Ethnic Violence in the Era of Globalization," considers, specifically, the brutality perpetrated by ordinary persons against those with whom they lived (or may or could have lived) in relative amity previous to globalization.[11] Despite the differences in each scholar's focus and approach, the key factors in their distinct discussions are the ways in which *uncertainty* figures into and affects violence.

In the first three chapters of *The Nervous System,* Taussig describes the organized violence in Colombia of police, other state officials, and paid militia against the poor and unrepresented, and he explicitly explains how fear and uncertainty was produced. By the "nervous system" Taussig means the continual creation and representation of crisis or emergency against the backdrop of order—"the illusion of order congealed by fear."[12] He explains the processes by which the Colombian government, state officials, and military police—the very ones who perpetrated the violence and uncertainty in the country—identified the dispossessed, the victimized, and the poor as *the cause* of their country's societal destabilization. Through the force of a violent militia and media

propaganda, the people who supposedly made up this collective and sinister "other" were criminalized and identified as guerillas, transvestites, prostitutes, drug dealers, and so on; their "disappearances" were never publicly or officially acknowledged.

He complicates this part of his discussion by writing to/about his anthropologist colleagues (and other academics) in such a way as to destabilize them. By placing them in the same role that they place their subjects, he writes to provoke them into seeing themselves as anthropologizing, and anthropologized, subjects. He suggests that they, professionally, stop attending to aboriginal material culture and peoples in terms of existing theories, methodologies, and discourses, especially as these intersect with ongoing colonial nationalist projects. These theorists/theories, he says, have obscured the violence of colonial history to help build "beautiful" national histories. He writes as witness to various kinds of institutional and national violence, not only providing anecdotal "evidence" of what it was like to live with the "disappeared" in Colombia in the 1980s, but parallel to that, what it is like to live nervously with the violence and terror within institutional practice in his own country. In writing about his various experiences as case studies, or as narrative histories using various literary forms such as autobiography, short story, anecdote, memoirs of his own dreaming, or ongoing nightmares, he uses both form and content to add a fragility to the text that inspires both empathy and horror.

Appadurai's consideration of violence in his essay, "Dead Certainty," is not as intimate or descriptive as Taussig's; rather, he sets out to explain the *nature* of ethnic violence within certain conditions of globalization and defines the role of uncertainty in it. In both this essay and his more recent book, *Fear of Small Numbers: An Essay on the Geography of Anger* (2006), he takes a turn from an earlier project (*Modernity at Large,* 1996) in which he examined the post-1989 emerging world of globalization in which migration and media technology play significant roles in the end

of the era of the nation-state; in its stead he proposed the imagination as a new resource for identity and for creating alternatives to nationalism and bounded geographies.[13] However, ensuing critiques that his earlier views were "naively cheerful" and did not pay sufficient attention to "the darker sides of globalization"[14] as destabilizing forces that would pit one cultural group against another led Appadurai to a deeper examination of the subject. In response to these critiques, he departs from his earlier discussions about the way images, lifestyles, popular culture, and self-representation are taken up in inventive ways in the globalized world and turns to a consideration of how ethnicity, race, and the culturalization of politics have resulted in a resurgence of violence in the post-1990s.

Porous borders and the deformation of local and national spaces, and exponential increases in migrants and refugees, provide the conditions for constructing enemies of those who previously, if not "kith and kin," were still neighbors, Appadurai says. However, with the global creation of large-scale ethnic categories or identities such as, for example, "Latino" or Latin American," or binaries, as in the cases Appadurai researched for his study (the Hutu and Tutsi, Sikhs and Hindus, and the "state citizens" and "class enemies" in China), neighbors and communities have been refigured and pitted against each other in various ways, including through mass-mediated images.[15] These representations circulate in the media and between people as "propaganda, rumour, prejudice, and memory" and do not necessarily have referents in empirical reality.[16] Nonetheless, as representation they still produce effects—one of the most significant being "them amongst us." In other words, the nation-as-unstable-entity becomes the uncertain ground of uneasy relationships with diasporic people, who further loosen the glue that attaches individuals to national ideology.[17] At the same time, the state surveys and classifies populations, determining who gets classified as a national minority and majority, at once defining who is the "them" amongst "us."

Appadurai makes abundantly clear that representations of biography, race, and identity still matter, specifically in relation to creating divisions of hatred and difference. This aspect of Appadurai's study overlaps in a limited way with Belmore's various references to violence in the world at large, specifically to the works in which she collapses images of local and regional issues of violence with global ones. But closer than this is Belmore's own context as a performance artist who is a visible minority and identifiable as an "Indian" woman (possibly from anywhere in the Americas). Since issues surrounding the fictions of race and the reality of racism persist in parts of Canada (including how they intersect with other power imbalances of gender and economy), it makes sense to assume that she also confronts such issues in the process of her works' production and dissemination, which complicates any reading of Belmore's work.

One such work was the performance *Vigil* (2002),[18] which was concerned with the local "disappearances" and murders of women from the Downtown Eastside of Vancouver, most of whom were sex-trade workers.[19] Although concerned friends and family and other citizens had been asking authorities to investigate the disappearances since the early 1980s, an investigation was not launched until 2001. A man was arrested and accused of killing twenty-six of the missing women; he stood trial for six of the murders and was found guilty of second-degree murder. As of 2002, women were (and still are today) "disappearing" in that area. In response to public outcry, police opened up the investigation and included in the list other missing women. Of the sixty-five women officially listed, *more than one third are of aboriginal descent,*[20] a high percentage given the fact that aboriginal people make up only one percent of the population of Vancouver.[21] Given the disproportionate number of aboriginal women "missing," racism and the lateral effects of colonialism must be figured into the whole situation—not just the women's murders and disappearances, but their being in the situation

and space in the first place. Regardless of these facts, or Belmore's lived cultural experiences as a performance artist who is Anishinabe and a visible minority in terms of the more classic forms of identity (race, class, and nation), and regardless of the degree to which these aspects of her life may inform her work, *Vigil,* as is performance art itself, is a collapse of the elements that make up an action. These elements include any or all of the following: the body (as an object that is both hers and not hers); any or all references to the murder of the women; the performance site in the alley; and the audience. The performance was an artwork, as is the video installation, *The Named and the Unnamed,* which was produced from the work's documentation (FIG. 6).[22] As such, these works or representations cannot be reduced to polemic, or a political protest based on aspects of Belmore's "identity"—which is not to say that any audience member may participate in a performance, or see the video, in that way.[23]

Both the performance and the video installation were created and exhibited so as to disturb the viewer, although certain aspects of Belmore's performance could be taken as a series of rituals that signaled some kind of closure, as in a funeral ritual: washing the site, lighting candles, calling out the women's names, the silent onlookers. But she *yelled* out their names, which were written on her arms; tore roses through her teeth; and nailed the red dress she was wearing to telephone posts in the alley where some of the women disappeared and continually ripped it away until it was completely shredded. Through this series of actions, she pointed the audience to traumatic violence and losses that were so deep that they could not be translated into something to be transcended or redeemed with meaning, or perhaps even spoken.[24]

Historian Saul Friedländer argues for the *absence* of meaning in such violence; he has argued in relation to the Holocaust that any attempt to make meaning through representations of it is to presume that such violence and meaningless suffering can be redeemed with significance,

can be given a moral dimension suggesting hope. Such attempts at redemption bring closure, which does not allow for what he describes as an "uncanny" history, the kind of history that *sustains uncertainty* and allows us to live without understanding or redemption.[25] For me, these particular ideas of Holocaust theory can be applied in limited ways to considerations of the conventions of performance art itself, and more specifically to trauma in aboriginal performance. To begin with, *uncertainty* is embedded in the form of performance art; the oscillating constellation of meanings arising from its enactment creates its own subtext of fragility. In many of Belmore's works, "disappeared" people, events, and histories are brought to the surface, emerge for a time, and then disappear from view. It is this emergence and disappearance, which circulates tenuously in public memory and in durational time, that makes the histories to which she refers "uncanny" and disturbs the ground in which they have been buried. Another distinctive mark in her works about trauma is that they are not confined to making broad reference to catastrophes or to "colonialism" in general (although these are often a part of the deep histories to which she refers). Her works are informed by the details of particular cases (see appendix A) *and* they refuse accepted "facile linear narratives" about them.[26] Performance, installation, and photograph work to disturb, but without excessive and self-reflexive references to historic trauma and violence as an end in itself.

A comparison can be made of the ways in which Belmore and Taussig figure specific histories into their work. It is obvious that the case of the missing women from Vancouver's Downtown Eastside, and the way it was treated by local officials, parallels Taussig's description of how the Colombian government used the media to create a collective sinister "other" and how state authorities refused to address the "murdered" as opposed to the "missing." In Vancouver, municipal authorities, at the beginning of the serial murders, were complicit in creating and sustaining images of these women as criminal, as "other," as people to be

feared, rather than as persons who are poor, oppressed, and missing. This is an important aspect of the ongoing "archaeological" uncovering of the situation and its significance as an international human rights issue. However, to return to Belmore's engagement with this history in her art-work *Vigil,* which is not political protest or historical corrective, Taussig, in contrast, represents the resistance of the women in Colombia as their doing battle with the state over the representation of their histories. He writes an historical narrative about how the mothers and wives of those who were violently tortured and murdered chained themselves to a government building and used the prerogative of motherhood (as a social sign) to publicly name their disappeared sons and daughters. Through this act, the women reclaimed their role as protectors in opposition to media images of the government as protector of women and children.[27] Taussig goes on to argue that this act effected private and public change: the women's private nightmares about their dead finally ended, along with the public silence. The names of the violently murdered were restored to public memory, and the living and their dead reconverged in chronological time.[28] In this part of his text, he writes a narrative of redemption and closure. But trauma is permanent; this is part of its definition. It can't be erased. Here, his story stalls, as would any argument that positions Belmore's performance as an heroic gesture of social and political protest against state and social violence.

*I*n *White Thread* (one of two staged photographs; the other, *Bloodless,* depicts a woman almost completely draped in white, with a shock of black hair exposed), the model is bent over and wrapped in red fabric (with a line of white thread sewn on its edges) from face to ankles; her wrapped face faces her knees, and wrapped arms and legs are bound together from elbow to ankle (FIG. 7). With one foot atop the other, and hanging black hair almost touching bare brown feet, she is bent in what

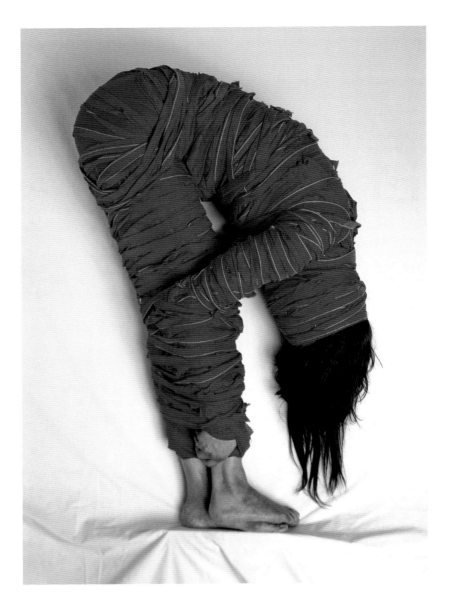

FIG. 7 **_WHITE THREAD_**, 2003, REBECCA BELMORE

INKJET ON WATERCOLOR PAPER, AP 2/3; 48 × 36 IN.

is clearly an untenable position against a white backdrop that also covers the small plinth on which she stands. In 2003, when these photographs were produced, Canada had just entered into the war against Afghanistan, and Belmore was thinking specifically of women and that war. This image may not reveal how ethnicity, race, and cultural politics have been constructed in the media since 9/11, but a work such as *White Thread* is a red flag.[29] Ethnic violence, Appadurai argues, has (among other things) resulted in "the return of the body of the patriot, the martyr, and sacrificial victims into spaces of mass violence."[30] He concludes in *Fear of Small Numbers* with the warning that if the world at large does not begin to understand how and why ethnicity, race, and cultural politics are constructed, if we do not understand the nature of global forms of violence, we will say "goodbye both to civilians and to civility."[31]

We see in Belmore's *Fringe* a representation of a body that may seem to fit this idea of the return of the martyr or sacrificial victim (FIG. 8). First exhibited in September 2007 as an 8-foot by 24-foot billboard on a busy freeway in Montreal, the image is of a brown-skinned woman lying in repose on a covered white platform, her back to the viewer, nude except for a sash of white cloth over her hips and a diagonal slash across her back, with red beads "embroidering" the length of the wound and cascading onto the platform. Situated just above the offices of the Grand Council of the Crees (at 277 Duke Street, Montreal), *Fringe* maps complicated

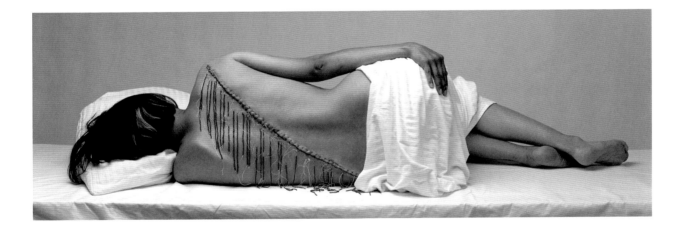

intersections of mass-mediated images of violence, conflated populist and nationalist signs, and representations of the "other" that resonate with those that circulate at global levels. Locally and nationally, brown skin and beads call up many popular essentialisms (which have been part of the culturalization of politics by both First Nations and Canadian governments), as they are linked to concepts of "the Indian" of Canada, the United States, and countries of the Southern Hemisphere.[32]

The many slippages and possible referents for the disturbing and powerful image of the body in *Fringe* in terms of its form, site, and possible audience complicate any literal or narrative reading. The installation itself may seem, at first or second glance, to be reduced to the cut across the woman's back—the vivisection, an assault on a woman and/or a visual assault on the viewer. But at second or third glance, the woman's back provides the viewer with an equivalent, yet absent image. As the viewer/driver moves in his or her car from one point to another, the billboard is seen in the blink of an eye: first, a woman slashed and dripping blood; next, a woman with a wound that is beaded with a red fringe. As a kind of filmic frame, the suture as a focal point in *Fringe* also points to an inside and an outside: the viewer "outside" and the brown-skinned beaded Indian woman's "inside." By this I infer the part of her body that is hidden as an "inside," inaccessible to an "outsider." This inside image is equivalent to the outside vulnerable and violent one—or vice versa. If we take this idea of insider/outsider further to the example of a viewer/commuter who passes by the work regularly for its three-year installation (2007–10), the confinement of the car, the isolation of the viewer, and the inaccessibility of the woman on the billboard create a space for the driver to make "insider" or self-referential meaning of the image over time and in glimpses. But here, I begin to write a particular kind of art history more about spectatorial competence and interpretation than art criticism and theory per se. In this limited discussion of *Fringe* I want to underline that any image viewed over time and perhaps in conscious reflection cannot simply be taken as a visual assault, or as one of the

many shocking images that now circulate the globe in unprecedented velocity via electronic technology. The image, the way it is exhibited in Montreal, the site, and the time frame of its exhibition, much like performance art, is *not intended to create an articulate response.*

This is also true of the paradoxical ways that Belmore combines certain themes and materials in other works: themes of motherhood and death and materials such as wine and milk (the curdled mix of spilled wine and coconut milk in *Crimes of Passion in Paradise and Beyond,* FIG. 9) and in her references to metaphorical, archetypal, and actual mothers, e.g., the Earth as the mother and water as the Earth's blood in *Fountain* (FIG. 10).[33] In her performance *Painted Road,* created to honor artist Daphne Odjig, and in reference to Odjig's painting, *From Mother Earth Flows the River of Life,*[34] Belmore "paints" the road in the rain at dusk by pushing bags of a mix of earth and iron oxide up a small hill to the car where Odjig sits, watching blood-red earth stains spread over a wet pavement, spotlit by her car's headlights (FIG. 11). All of the various elements in Belmore's work may raise questions for an audience, but they do not offer answers or resolution or any specific call to action—just a nervous uncertainty.

*I*mages of violence in art cannot be seen separately from the post-1989 globalized world described by Appadurai, in which "moving images meet mobile audiences";[35] nor can they be entirely separated from the barrage of media arising post-9/11 and from the wars in the Middle East—such as videos of public beheadings and other kinds of violence that have been used as tools for political expression. Since most people have been exposed to these media images, the violence in Belmore's works may shock and unsettle a viewer who has seen such violence; her work may reactivate mental images previously seen on television; a work can call up any number of narrative strings, triggering past shocks inscribed in the body. So is she, as artist, implicated in

36

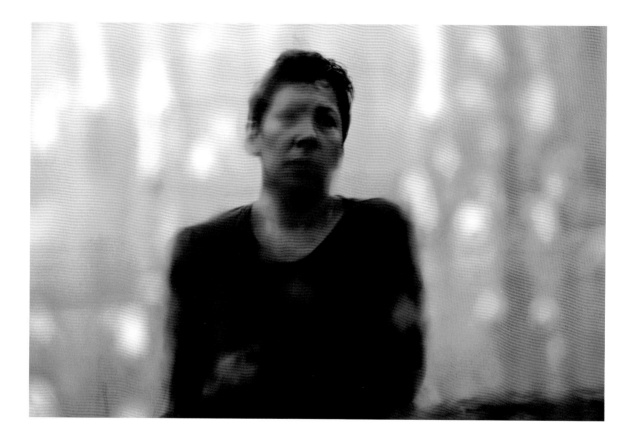

FIG. 10 *FOUNTAIN*, 2005, REBECCA BELMORE

PRODUCTION STILL

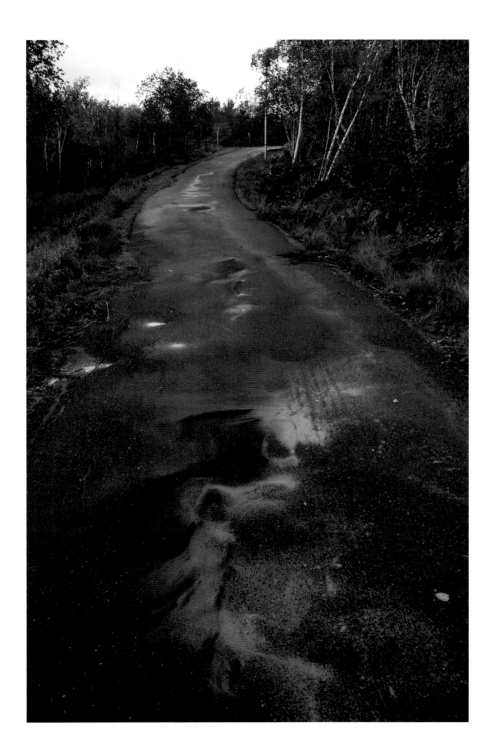

FIG. 11 **PAINTED ROAD**, 2007, REBECCA BELMORE

PERFORMANCE IN HONOR OF DAPHNE ODJIG'S PAINTING *FROM MOTHER EARTH FLOWS THE RIVER OF LIFE*, GRAVEL ROAD BEHIND THE ART GALLERY OF SUDBURY, LAURENTIAN UNIVERSITY, SUDBURY, ON

constructions of violence that perpetuate more violence, or add to the degree to which audiences may become inured to it due to overexposure? Are we as audience/writers implicated? Yes, I would say to both questions, insofar as any work about violence is necessarily complicated by the paradox of taking it as subject matter in the first place: we "represent" it, and representations of violence are always double-edged, even those that are self-consciously produced to "introduce alternative interpretations [of an event], question any partial conclusion, [and] withstand the need for closure."[36] One need only look at the titles of some of Belmore's works—*Creation or Death: We Will Win* (1991), *Blood on the Snow* (2005), *The Capture of Mary March* (2005), *Making Always War* (2008)—to see that she includes representations of violence with an understanding of how it is constructed and produced in the globalized world, which is perhaps one of the reasons that she, like Taussig and Appadurai, seem compelled to address the subject in ways that create a shift in consciousness.

That said, for those who are compelled to investigate violence, Friedländer writes that the resulting *emotional impact* and the *protective numbing* of such research and writing cannot be avoided, and further, that both are "necessary" for keeping one's balance.[37] These are the inherent contingencies and contradictions of both making and "reading" such work.

Trauma is a marking. And since its mark is also visceral, somatic, and cellular, mental knowledge or consciousness doesn't necessarily come into play. Staying mentally alert does not necessarily stop one from falling into the body or the past in the middle of a performance. At the same time, in that defenselessness, in the specificity of the artist's uttering, you are no longer able to respond with mind, to judge or elaborate. You experience the destruction of an angle of repose. So you leave at the end of the performance, still in its middle, without the consolation of closure or meaning. Alive and disturbed.

NOTES

1. Born in Upsala, Ontario, of Anishinabe heritage and currently living in Vancouver, Belmore has exhibited both nationally and internationally and was the official representative for Canada at the Venice Biennale in 2005.

2. These works are either discussed in the text or in appendix A.

3. These two types of trauma are given, respectively, the terms "Trauma 1" and "Trauma 2" by Judith Herman in *Trauma and Recovery: The Aftermath of Violence—from Domestic Abuse to Political Terror* (New York: Basic Books, 1997), 139.

4. Essays about the body and performance art, or more specifically "action" art history, include Richard Martel, "The Tissues of the Performative," in *Art Action: 1958–1998* (Québec: Editions Intervention, 2001), 32–61; Malcolm Green, "Introduction: Hall of Mirrors," in *Brus, Muehl, Nitsch, Schwarzkogler: Writings of the Vienna Actionists,* ed. Malcolm Green (London: Atlas, 1999), 9–20; and Nelly Richard, "Margins and Institutions: Performances of the Chilean Avanzada," trans. Paul Foss and Juan Davila, in *Corpus Delecti: Performance Art of the Americas,* ed. Coco Fusco (New York: Routledge, 2005), 183–97. Writing about performance artists Diamela Eltit and Carlos Leppe, Richard quotes Eltit as saying she works in zones of pain not to morally change them but "to show that they exist . . . individual pain confronting collective pain" (ibid., 189).

5. Although there is no telling when or to whom the state of autonomic hyper-arousal will occur, given the history of aboriginal peoples in Canada, it follows that the possibility of being retraumatized is high for a First Nations spectator. See Herman, *Trauma and Recovery,* 139.

6. Ibid., 174.

7. Frazer Ward, "Some Relations between Conceptual and Performance Art," *Art Journal* 56, no. 4 (Winter 1997): 36–40.

8. Benjamin Buchloh in "The Reception of the Sixties," by Rosalind Krauss, Denis Hollier, Annette Michelson, Hal Foster, Silvia

Kolbowski, Martha Buskirk, and Benjamin Buchloh, *October* 96 (Summer 1994): 18.

9. I draw from and quote the work of Martel, "The Tissues of the Performative," 32 (see n. 4).

10. Michael Taussig, *The Nervous System* (New York: Routledge, 1992).

11. Arjun Appadurai, "Dead Certainty: Ethnic Violence in the Era of Globalization," in *Globalization and Identity: Dialectics of Flow and Closure,* eds. Birgit Meyer and Peter Geschiere (Toronto: Wiley Blackwell, 1999), 305–24.

12. Taussig, *The Nervous System,* 2.

13. Arjun Appadurai, *Fear of Small Numbers: An Essay on the Geography of Anger* (Durham: Duke University Press, 2006) and *Modernity at Large: Cultural Dimensions of Globalization* (Minneapolis: University of Minnesota Press, 1996).

14. Appadurai, *Fear of Small Numbers,* 3.

15. Appadurai, "Dead Certainty," 305–24.

16. Ibid., 305.

17. Ibid., 907, 920.

18. Marcia Crosby, "Humble Materials and Powerful Signs: Remembering the Suffering of Others," in *Rebecca Belmore: Rising to the Occasion,* eds. Daina Augaitis and Kathleen Ritter (Vancouver: Vancouver Art Gallery, 2008).

19. Suzanne Fournier, "Women Went Missing after Police Alerted," *The Vancouver Province,* February 27, 2002.

20. Suzanne Fournier, "Eight Names Added to List of Missing Women," *The Vancouver Province,* October 7, 2004.

21. *Aboriginal Peoples in Canada in 2006: Inuit, Métis and First Nations, 2006 Census: First Nations People;* http://www12.statcan.ca/english/census06/analysis/aboriginal/fewer.cfm. Last accessed April 2, 2009. Less than 4% of the population of British Columbia is native.

22. The documentation by Paul Wong was produced as a video installation and exhibited at the Morris and Helen Belkin Art Gallery, University of British Columbia, Vancouver, BC, in 2002.

23. The issue of politically and aesthetically based art is discussed in Mary Beth Tierney-Tello, "Testimony, Ethics, and the Aesthetic in Diamela Eltit," *PMLA* 114, no. 1 (January 1999): 78–96. Tierney writes that "in a book of literary criticism, the Peruvian writer Mario Vargas Llosa points out that because literature in Latin America has given voice since colonial times to what governments and the ruling classes repressed, a conception of literature as truly reflecting reality, as morally edifying, and as politically revolutionary, has evolved there . . . While for Vargas Llosa this conception of the role of literature impoverishes and deadens art, for others such commitment is necessary to an ethical response to the often embattled Latin American social context. Indeed, many left-leaning critics consider art for its own sake in Latin America politically suspect and even irresponsible" (ibid., 78).

24. Regarding the testimony of Holocaust survivors, Lawrence L. Langer says: "Surviving victims bear witness to the impossibilities of their lives then; we tend to translate them into possibilities by easing them into chronological time as wounds to be healed, insults to be paid for, pain to be forgotten, deaths to be transcended or redeemed. Martyrdom or the notion of dying with dignity reestablishes the communal 'we' that makes the victim's death . . . a 'shared' experience with the future and the past . . . Martyrdom and dying with dignity not only furnish an unthreatening form of discourse, but restore the individual victims to the stream of humanity in time and thus rescue them from anonymity." Lawrence L. Langer, "Memory's Time: Chronology and Duration in Holocaust Testimonies," in *Admitting the Holocaust: Collected Essays* (Oxford: Oxford University Press, 1995), 19, 20.

25. James E. Young summarizes this aspect of Friedländer's position regarding an "uncanny history" in "The Holocaust as Vicarious Past: Art Spiegelman's *Maus* and the Afterimages of History," *Critical Inquiry* 24 (Spring 1998): 666–99.

26. Friedländer says that "such commentary may introduce splintered or constantly recurring refractions of a traumatic past by using any number of different vantage points." Quoted in James Young, review of *Memory, History, and the Extermination of the Jews of Europe,* by Saul Friedländer, *Criticism* (Winter 1996): 3. Available at http://www.findarticles.com/p/articles/mi _m2220/is_n1_v38/ai_18125697. Last accessed May 4, 2009.

27. Richard Fox, review of *The Nervous System,* by Michael Taussig, *American Anthropologist* 95, no. 1 (March 1993): 188, 189.

28. For a discussion of chronological time in relation to redemptive narratives, see also Saul Friedländer, *Memory, History, and the Extermination of the Jews of Europe* (Bloomington: Indiana University Press, 1993); Dominick LaCapra, *Representing the Holocaust: History, Theory, Trauma* (Ithaca, NY: Cornell University Press, 1994); Lawrence L. Langer, *Holocaust Testimonies: The Ruins of Memory* (New Haven, CT: Yale University Press, 1991); and Langer, "Memory's Time: Chronology and Duration in Holocaust Testimonies."

29. Crosby, "Humble Materials and Powerful Signs."

30. Appadurai, *Fear of Small Numbers,* 12.

31. Ibid., 137.

32. Robert Enright, "The Poetics of History: An Interview with Rebecca Belmore," *Border Crossings* 95, no. 3 (August 2005): 63.

33. Belmore refers to water as the life-blood of the Earth, an idea that, she says, "comes from the periphery of Anishinabe knowledge." But, she says, it is through her own art practice that she finds connections to these ideas, and "art allows [her] to give them visibility in the wider world." Rebecca Belmore quoted in Jessica Bradley and Jolene Rickard, *Rebecca Belmore: Fountain* (Vancouver: Morris and Helen Belkin Art Gallery, 2005), 26.

34. Performance: *Painted Road,* at the Art Gallery of Sudbury, Sudbury, Ontario, October 11, 2007.

35. Annette Baldauf and Christian Hoeller, *translocation_new media/art: "Modernity at Large"* (interview with Arjun Appadurai, 1999; http://www.appadurai.com/interviews_baldauf.htm. Last accessed April 2, 2009.

36. Friedländer, quoted in Young, "The Holocaust as Vicarious Past" (see n. 25).

37. "The major difficulty of historians of the Shoah [Holocaust], when confronted with echoes of the traumatic past, is to keep some measure of balance between the emotion recurrently breaking through the 'protective shield' and numbness that protects this very shield. In fact, the numbing or distancing effect of intellectual work on the Shoah is unavoidable and necessary; the recurrence of strong emotional impact is also often unforeseeable and necessary." Saul Friedländer, "Trauma and Transference and Working Through," in *The Holocaust: Theoretical Readings,* eds. Neil Levi and Michael Rothberg (New Brunswick, NJ: Rutgers University Press, 2003), 209; 206–13.

APPENDIX A: SELECTED WORKS OF REBECCA BELMORE

1. *Creation or Death: We Will Win* (IV Bienal de la Habana, Cuba, 1991): Performance in a historic colonial building, Castillo del Fuerza. References the slaves who built the Castle of Strength.

2. *Bury My Heart* (Material Culture, group exhibition, Paris Gibson Square Museum, Great Falls, Montana, August 15, 2000): References the following history: In the winter of 1890, three hundred Oglala Sioux, most of them women and children, were massacred by the U.S. Cavalry at Wounded Knee Creek, South Dakota. Their bodies were left exposed in the snow.

3. Video installation titled *March 5, 1819* (installed at The Rooms Provincial Art Gallery, St. John's, Newfoundland, 2008): A reenactment of the abduction of the last Beothuk, Mary March. The installation features selected collection holdings of The Rooms and the original miniature portrait of Demasduit (Mary March) on ivory by Lady Henrietta Hamilton (ca. 1780–1857) on loan from Library and Archives Canada. Two screens are positioned opposite each other, each providing distinct points of view for Belmore's abduction narrative. Dressed in contemporary clothes, March and her husband are tracked by the camera as they run for their lives. The looped 2:30-minute dramatic narrative references the following history: On March 5, 1819, British settlers at Red Indian Lake in Newfoundland abducted a young Beothuk woman named Demasduit. They called her Mary March. The

settlers intended to hold her in captivity for ten months to show her they intended her no harm, after which (it is said they believed) they would be able to establish better relations with the Beothuk. Demasduit's husband was murdered during the abduction, and Demasduit died later—before her release. Other works related to the subject: *Shanawdithit, the Last of the Beothuk* (2001): A sculptural installation of "a body" limited to a pair of hands and feet. The hands sit on a shelf with skeins of black hair protruding from the wrists; the feet are on the floor directly underneath the shelf; and *The Capture of Mary March* (2005), a series of three photographs of a model in a modern salon (one of her sitting in a chair, one of her standing, and one of her kneeling in front of the chair with her head on the seat). In each photograph, the chair is surrounded by a ring of fire.

4. *A Blanket for Sarah* (1994): In memory of a woman who froze to death on the street in the city of Sioux Lookout, Canada. The work consists of twelve panels of thousands of pine needles threaded through wire mesh, framed in wood. See Augaitis and Ritter, *Rebecca Belmore: Rising to the Occasion,* 30–31.

5. *For Dudley* (Teratoid Cabaret, 7a*11d International Performance Art Festival, Symptom Hall, Toronto, Ontario, August 8, 1997): References the killing of Dudley George, a young native man of the Kettle and Stoney Point First Nation, who was shot and killed by an Ontario Provincial Police sniper in 1993. The police fired on him while he was occupying a sacred Indian burial ground (Ipperwash Park). Dudley George was holding a stick; the police said they thought it was a gun. For details, see Augaitis and Ritter, *Rebecca Belmore: Rising to the Occasion,* 100.

6. *Vigil* (2002): Belmore's performance, which took place June 23, 2002, was concerned with the murders of women from the Downtown Eastside of Vancouver, most of whom were sex-trade workers. This performance, documented and edited by Paul Wong, was reproduced as a video installation titled *The Named and the Unnamed,* which was acquired by the Morris and Helen Belkin Art Gallery. See also the exhibition catalog *Rebecca Belmore: The Named and the Unnamed* (Vancouver: University of British Columbia Press, 2003).

7. *Crimes of Passion in Paradise and Beyond* (Centre for Caribbean Contemporary Art, Port of Spain, Trinidad, 2002): A work based on a newspaper article in Trinidad about a young mother and her infant who were murdered with a machete. For images, see Augaitis and Ritter, *Rebecca Belmore: Rising to the Occasion,* 105.

8. *Walk of the Righteous* (2003): A performance based on the police-assisted freezing deaths in Saskatchewan, which was part of *Hearts on the Ground: Group Performances,* Sâkêwêwâk Artists' Collective, Regina, Saskatchewan, June 14, 2003.

9. *Freeze* (2006): This installation also references the police-assisted freezing deaths (see *Walk of the Righteous,* above). Darrell Night was dropped off by two police officers in -20°C temperatures in a field outside Saskatoon in January 2000. He survived, but the frozen body of another aboriginal man was discovered in the same area. Days later, another aboriginal victim was found. When Night came forward with his story, his action led to a Royal Canadian Mounted Police investigation into other freezing deaths and the conviction of the two constables who had dropped Night off on the outskirts of the city. The 1990 case of Neil Stonechild, a First Nations teenager who died of hypothermia, was then reopened, concluding in a judicial inquiry. See "Neil Stonechild: Timeline," *CBC News Online,* updated November 3, 2005; http://www.cbc.ca/news/background/stonechild/timeline.html (last accessed April 2, 2009). See also Tasha Hubbard's film *Two Worlds Colliding* (2004); http://www.nfb.ca/collection/films/fiche/?id=51081 (last accessed April 2, 2009).

10. *Making Always War* (2008): A performance at the University of British Columbia, Vancouver. Belmore and an artist assistant arrive just before sunset in a red pickup truck, with windows open and powwow music playing. They park outside UBC's Belkin Art Gallery. Belmore takes sand, nails, and a hammer over to a small cement pedestal, which she covers with sand. Then they carry a salvaged piece of square timber to the pedestal and return to the truck. The assistant drinks beer while Belmore takes six neatly folded "Desert Storm" camouflage shirts back to where the wood lies flat on the ground and drops the shirts, three on each side. She rips each shirt open at the buttoned front and nails them to the edges and flat surface of the wood, completely covering it, which takes forty-five minutes. The work is raised upright. Belmore circles it, looking closely at its finish, steps back, stands quietly, gets in the truck, drives up dangerously close to the pole, and then backs away. She and her assistant leave the site, powwow music still wailing.

FIG. 12 **WOUNDED KNEE MEMORIAL** (DETAIL WITH CHIEF BIG FOOT BODY), 1991, EDWARD POITRAS

DETAIL OF INSTALLATION AT THE DUNLOP ART GALLERY, REGINA, SK

EVOKING HEROISM IN FLOYD FAVEL'S SNOW BEFORE THE SUN

Polly Nordstrand

I had a vivid dream of this photograph [Big Foot's Corpse at Wounded Knee]. In my dream I was an observer floating—I saw Big Foot as he is in the photograph, and my heart ached. I was about to mourn uncontrollably when into the scene walked a small child, about six years old . . . Her small moccasin footprints imprinted the snow as she walked over to Big Foot, looking into his face. She shakes his shoulders, takes his frozen hand into her small, warm hand, and helps him to his feet . . . He then takes her hand and they walk out of the photograph. This is the dream I recall when I look upon this image of supposed hopelessness.

—HULLEAH TSINHNAHJINNIE, "WHEN IS A PHOTOGRAPH WORTH A THOUSAND WORDS?"[1]

The disturbing photograph of Chief Big Foot's body crumpled and frozen between a sitting and lying down position was made in the wake of the massacre at Wounded Knee Creek. The photographer, George Trager, had been drawn to the Pine Ridge Indian Reservation several times that year beginning in March 1890 in an effort to capitalize on the

events at the reservation, especially the reported tensions between the military and the Lakota residents. Trager had established a photography studio in Chadron, Nebraska. His business focused on the local tourist economy, selling pictures of the American West to railroad travelers who made the stop before moving on to South Dakota on their way to the spas of Hot Springs or the gold mining towns like Deadwood. He was one of the first photographers to be on the scene in the days following the massacre, which took place on December 29, 1890. He and Clarence G. Moreledge photographed the landscape and the dead, while others dug mass graves and searched the snow-covered ground for relics. Some of the details of the photographs were too graphic even for an audience that clamored to see the annihilation, and the negatives were carefully reviewed and altered to spare viewers from having to see a naked body among the deceased.[2] The gruesome images showed gunshot bodies scattered and piled in the field, their stiff arms and legs protruding from the wagon loads, adding to the awfulness of imagining the experience of the victims. The images soon became hot commodities as postcards in a mass marketing endeavor by the photographers.[3] The postcards eventually found their way into archival collections to become part of the historic record.

Historian Robert Venables wrote about the archives left behind: "I first obtained a microfilm copy of Baum's *Saturday Pioneer* in 1976, believing that I would probably find editorials which protested the massacre of Wounded Knee."[4] Instead he reports finding calls for the extermination of Indian people. We are devastated by the images of the massacre, but at the time the victims were seen by the soldiers and settler community as little more than outlaws. L. Frank Baum, well-known author of *The Wizard of Oz,* was editor and publisher of the *Aberdeen Saturday Pioneer* newspaper at the time of the Wounded Knee massacre. On January 3, 1891, the *Pioneer* published Baum's editorial about the

tragedy—which focused on the loss of soldiers who had been killed mainly by "friendly fire":

> *The peculiar policy of the government in employing so weak and vacillating a person as General Miles to look after the uneasy Indians, has resulted in a terrible loss of blood to our soldiers, and a battle which, at best, is a disgrace to the war department. There has been plenty of time for prompt and decisive measures, the employment of which would have prevented this disaster.*
>
> *The PIONEER has before declared that our only safety depends upon the total extirmination [sic] of the Indians. Having wronged them for centuries we had better, in order to protect our civilization, follow it up by one more wrong and wipe these untamed and untamable creatures from the face of the earth. In this lies safety for our settlers and the soldiers who are under incompetent commands. Otherwise, we may expect future years to be as full of trouble with the redskins as those have been in the past.*[5]

Venables notes that "the editorials at points are curiously ambivalent . . . But their core message is genocide. Like so many humans who are capable of uttering and doing the unthinkable, L. Frank Baum was in many respects a sensitive and loving man. But I don't believe it is enough to say that his editorials are an indication of how, in Baum's era, calls for genocide were not aberrations, that they were widely held, and that they were public."[6]

Of course, not everyone then or today thinks of the Indians dead at Wounded Knee as "outlaws." Artist/performer Floyd Favel was so deeply disturbed by the image of Big Foot's frozen body at Wounded Knee and the details of the massacre that he was compelled to create an original performance. Rather than focus on the victimization of the people of the Plains, he melded the tragic event at Wounded Knee Creek and the

beliefs of the Ghost Dance with the 1970s film icon Billy Jack to evoke the heroic nature of two men—one real, one fictional. The drama that unfolds is one of persecution and spiritual resistance.

I began working with Favel to present *Snow before the Sun* in Denver after it had already been staged as a rehearsal at the Sâkêwêwâk Story Telling Festival in Canada (March 2004). Favel accepted a residency at the Denver Art Museum, where he would study the collections to inform his performance and then stage it at the museum—perhaps within the newly installed *Wheel* outdoor sculpture by Cheyenne-Arapaho artist HOCK E AYE VI Edgar Heap of Birds. We decided having Favel as an artist in residence was beneficial to the museum for many reasons. One of these was his interest in how museum objects might provide stimulus for a performance. A second was his investigations into how to define or create performances that revealed Native aesthetic and intention.

When we began discussing the residency, he described his one-man show as more performance art than theater. Favel, who grew up on the Poundmaker Cree reserve in Saskatchewan, came to this project from a theater background. He is a writer, director, and actor. He is also widely known for his portrayal of a comedic character on the popular radio program *The Dead Dog Café Comedy Hour*. He began his formal theater studies at the Tukak Teatret in Denmark—a school for young Inuit, Sami, and aboriginal artists. He then spent three years at the Centro di Lavoro di Grotowski—a theater research center in Pontedera, Italy. Grotowski is known for his innovative theater techniques. He perceived theater as a laboratory. In his *Statement of Principles,* which he gave to prospective students, he described his theoretical approach to theater and acting as "a kind of vehicle allowing us to emerge from ourselves, to fulfill ourselves." Through his method, he intended for the actor to create an *integration* of physical and mental reactions. Theater would serve as a type of therapy for modern civilization, where people had created an artificial divide between body and soul.[7]

When Favel returned to Canada he found a great omission in theater study of indigenous practices, and this deficiency prompted his own investigations to develop contemporary indigenous theater. Beginning with his studies abroad, he has been open to cultural studies beyond strictly Canadian First Nations; he also studied under Japanese Butoh master Natsu Nakajima in 1994. Butoh remains an indefinable, avant garde performance art. Performances often take on tortured forms with bodies and faces contorting as the dancer tries to get at the primal essence of movements. The underground nature of the art form makes a stage unnecessary. The presence of an audience is optional. Understanding Butoh was a natural progression for Favel, who was interested in exploring art forms that allow artists to uncover their instinctive expressiveness.

Favel is an artist hungry for the understanding of history. Themes of historic events frequently run through his writings and investigations. He conducts extensive research in order to understand not only the event, but the experiences of the people who lived it and the landscape where the event took place. He absorbs all of this information as part of his creative process. Integral to his dance research for this project was image research. He was especially interested in looking at winter count drawings and took advantage of the collections at the Denver Art Museum and the Denver Museum of Nature and Science. The paintings/ drawings showed figures through time, in various periods of wellness and strife. Favel was curious as to how he might incorporate the mnemonic imagery into his own storytelling through narrative action. His investigation into Native Performance Culture had provided him the opportunity to teach a class in 2001 at Brandon University in Manitoba, which explored the idea that movements of the body could serve a narrative purpose similar to that of the winter count pictographs. In a collaboratively taught class with Lakota artist Colleen Cutschall, he led his students to examine a written text and then develop pictographic

images of the story that would become dance movement.[8] This was not the easiest exercise for the theater students. Favel offered them this encouragement to help free them of the tendency to recreate "realistic" forms: "Our life is based on stories, myths, legends and supernatural events. You can't express that with naturalism. Therefore it is logical to develop theatre systems that reflect supernatural realities, and to construct performances based on Native ways of montage, composition and structure."[9]

The object that had already provided motivation to create *Snow before the Sun* was the photograph of Big Foot's body at Wounded Knee.[10] Like many people, Favel was deeply affected by this image of death and brutality. The impact of seeing a photograph or learning the details of certain tragedies—like lynchings in the South, the beating of civil rights activists, the bombing of the World Trade Center, things unimaginable—is that we are stricken by the realization that if we had been born at the wrong moment, or in the wrong place, or had the "wrong" color skin, we could be that person who suffered unjustly. The artist Hulleah Tsinhnahjinnie described her heart breaking for Big Foot as if she were standing over the actual body lying in the snow. Although she describes a dream, this emotional empathy is a reality. This heartache was something that Favel carried with him for many years before he began to work on *Snow before the Sun*.[11]

Many other artists have created works in reaction to this image and the massacre at Wounded Knee (FIG. 12). This was not necessarily the most gruesome of the photographs, but it is iconic because the image of the betrayed leader, who had already surrendered to maintain peace, represents the torture endured by Indian people struggling to maintain their land and cultures—and in this case their lives. The Lakota professor of social work Maria Yellow Horse Brave Heart calls the continued suffering of Indian people from the effects of these past events "historical unresolved grief." The descendants of survivors experience not

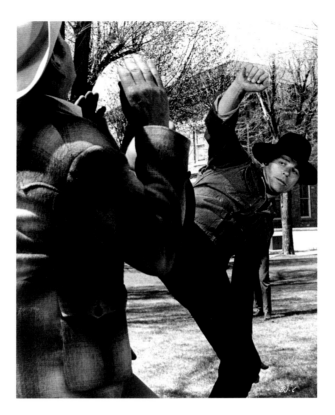

FIG. 13 *BILLY JACK (BILLY JACK KICKING LOCAL)*, 1971

MOVIE STILL

only anger and grief but may feel an obligation to share "ancestral pain." They may even feel guilt or shame that causes them to "feel responsible to undo the tragic pain of their ancestral past."[12] But there is no way to reach back and heal those who are gone. So what can we do to heal ourselves?

As I have described, Favel draws on a great diversity of experiences to inform his work. And the performance of *Snow before the Sun* was no different. In addition to the Wounded Knee photographs, he recalled the rebellious Billy Jack character from the 1970s cult film of the same name. The character Billy Jack (played by Tom Laughlin) is an ex–Green Beret Vietnam veteran and an expert at the Korean martial art, Hapkido (FIG. 13). His mixed heritage of white and Cherokee parents motivates him to "connect with his roots" by going to live on an Indian reservation

where he has taken up the role of protecting the wild mustangs from being hunted for dog food. Nearby is the Freedom School, an experimental school that accepts students of all races. That some scenes were filmed at the newly established Institute of American Indian Arts shows that Laughlin—who also wrote, directed, and promoted the film—was keenly aware of trends taking place in Indian country at the time, thanks to his cowriter Delores Taylor. Taylor had grown up in South Dakota and understood the tensions between white and Indian communities, having lived through it. The plot takes several turns involving the racism and violence of the local law enforcement and white community against the students, Indians, and women at the school—including the molestation of a minor and the rape of the school's director, Jean Roberts (played by Taylor). Billy Jack begins a vigilante's revenge. In one of the most memorable scenes in the movie Billy Jack takes on a group of bullies who had harassed the students while they tried to eat at an ice cream parlor. Calling them out to the city park, he uses his martial arts skills to defend the students. After a number of killings, the film ends with a shoot out, after which the wounded Billy Jack surrenders—but only after securing the future of the Freedom School.

In Roger Ebert's 1971 review of this inventive film, which he gave 2½ stars, he provides us with the current perspective of the film's violence: "I'm also somewhat disturbed by the central theme of the movie. *Billy Jack* seems to be saying . . . that a gun is better than a constitution in enforcement of justice. Is democracy totally obsolete, then? Is our only hope that the good fascists defeat the bad fascists?"[13] As a young person, Favel had seen this film and rather than being disturbed by hot-tempered Billy Jack's revengeful actions, he connected with the students in the film who suffered racial intolerance from the surrounding local white community. Favel had witnessed this same intolerance on his reserve. Favel admired the way Billy Jack stood up to the racists in defense of the Native youth—something that he hadn't seen in other

films or his own community. The iconic moments of this film became images that Favel internalized. Like the impression that had been made by the photographs of the Wounded Knee massacre, *Billy Jack* informed Favel's rethinking of the story of the Wounded Knee massacre.

The performance begins with the sound of horses, light piano notes, then the voice of a young woman revealing the disappointment she has already suffered in her life. Favel makes his way to the center of the stage. He situates himself on the same level as the audience, which sits on the floor or on stools around him in all directions. He is dressed as an old man; his head is covered with a black scarf; he wears gray pants and a suit coat. He is Big Foot. His improvisational movement indicates the spiritual leadership of Big Foot, his attempt to connect to the higher power. Several minutes into the performance gun shots ring out; he flinches at the imaginary bullets hitting his body (FIG. 14). We hear the dialogue of conflicts from the film. A mournful voice hums as he falls into the half-reclined position of Big Foot's frozen corpse (FIG. 15). We hear: "When policemen break the law, then there isn't any law." After an agonizing stretch of time in this half-lying pose, he moves. He sits up to retie the scarf around his face. The masked figure rises and feels his way in the darkness. The place is new to him. He walks and rolls through space as if there are no limits to his movement. Completing his exploration and acquaintance with this new world, he rests. The masked figure calls out in a muffled voice. And the act ends. Favel then rises, removes the scarf and coat to replace his old man costume with a cowboy hat—an invigorated persona. The newly emerged character engages in retaliating martial arts movements such as Billy Jack would have made (FIG. 16). Eventually he calms and walks to the four sides of the stage, claiming the space as his own. He drops to his knees and rests. And the performance closes.

Favel acts out the drama of persecution and spiritual resistance in silence. The soundscape, composed by Dene musician Leela Gilday,

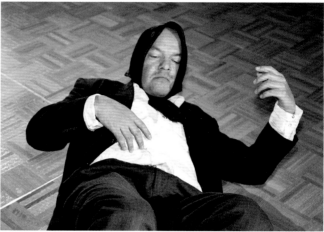

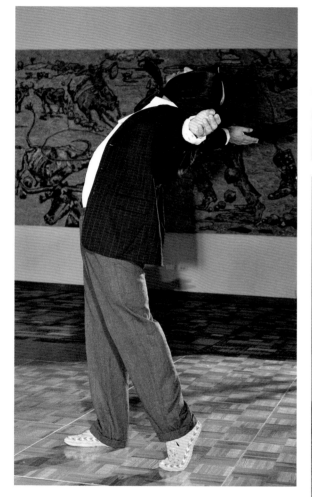

56

includes sparse dialogue excerpts from the *Billy Jack* film, and in so doing reinforces the suggested plot. Those familiar with the film recognize the scenes and recall related imagery. The recollection of imagery played a large role in the creation of this work, and Favel relies on the audience's familiarity with the massacre at Wounded Knee, including the photographs of the bodies, as well as the film *Billy Jack*. His movements are derived from the important moments. Similar to what he had his students attempt in the class exercise, he creates "pictographs" from the stories and reminds us of the more complete version through his narrative actions. In staging the performance at the museum, where we believed there would be a high number of people in the audience completely unfamiliar with Wounded Knee and the film, we made the decision to place the image of the frozen body in the program. However, we only described the film, since we hoped that the audience would gain understanding through the literal meaning of the words in the soundscape. Favel is not reenacting the event at Wounded Knee, nor is he recreating the plot of the film that influenced him as a young person. In *Snow before the Sun,* Favel compresses time and pieces together an Indian narrative out of historic memory, fiction, and personal experience. Theater professor James Forsythe describes Favel's storytelling from multiple points of view as "oscillat[ion], vocally, back and forth from first to third person, and physically from the presentational to the metaphoric or symbolic."[14] Favel takes the mythological from reality and the imagination to present a deeply moving story where we can find ourselves reflected in the actions.

Some artists try to create shock through performance; Floyd Favel instead deals with the shock of the images in the photographs as filtered through his performance in order for us to regain a sense of calm. He does not respond with words, but instead with movement and sound. He moves through transformative experiences, creating new scenes that allow us to process the killings at Wounded Knee or even the hatred we

might have experienced in our own lives. He presents the action and in this way does not implicate the audience, which is made up of people from all cultures, in the event—its racism and violence. Some of what Favel projects seems to be imagined as his own experience, which makes us consider again Dr. Brave Heart's explanation of how Indian people carry "historical unresolved grief." While the performance may be his own processing of these things, we experience it with him as witnesses. Instead of seeing Billy Jack's rebellious and violent reaction to the intolerant community as a tragic flaw, Favel saw a kind of heroic quality in the character, who would defend his community (the students and teachers of the Freedom School) at any cost to himself. By melding the two figures as defenders—one real and one fictional—Favel proposes that these two men were heroic guardians more than victims. He chooses to counter the initial heartache that we feel at the sight of death with a story of rebirth. He takes us beyond the death and violence to remind us that there is afterlife and the possibility of spiritual reawakening.

As with any other artwork, there is no way to fully understand the impact of this performance on the audience, because it takes time for people to absorb the event, recall it, and perhaps integrate it into themselves. The immediate reactions that were shared with us mainly came from audience members who had an understanding of the massacre and knew the film. One audience member recalled the scene in the film where the students attempt to buy ice cream, along with a similar event in her own life where her Indian/Mexican family was ignored while trying to get served ice cream at a restaurant in Wyoming near her reservation. Her white companion was shocked by the blatant discrimination, but she told him it wasn't unusual.

A theme that persists in Favel's work—mainly in his writings—is that of love, especially romantic love. The partnership of Jean Roberts and Billy Jack was more prominent in the first iteration of this performance, the rehearsal in Canada. But it continued in the Denver Art Museum

version through moments of verbal exchange between the two characters presented in the soundscape. Jean is the nonviolent foil to Billy Jack. In the film she urges him to back down from his enraged standoff. In the performance soundscape we hear her reason with him: "I only know you can't stop everything by violence, Billy." These words echo out of the quiet and are absorbed throughout the rest of the performance. Her rationality and tenderness also help us to process the visceral reaction that we might have to learning about the violence against Native people. She gives us an alternative way to respond just as she is trying to give Billy Jack an alternative. Even when the gun shots ricochet out from the soundscape we hear Jean say to Billy, "Someplace where it doesn't have to be like this." Billy responds, "Oh, really, well tell me where is that place? Where is it? In what remote corner of this country, no, the entire god damned planet, is there such a place where men really care about another and really love each other? Now you tell me where such a place is and I promise I'll never hurt another human being as long as I live. Just one place." This exasperated frustration and disgust is one that many Indian people feel about how their people have been and are treated. The hopeful tenor of Jean's words reminds us that there is a place to move away from the disappointment and mistrust. We begin to imagine what that place might be, and our focus shifts from devastation to a tentative hopefulness.

By means of this performance we are given an extended vision of the impact of events like the massacre at Wounded Knee. We see the afterlife of the fallen victim. We also see the frustration of future generations, but we are presented with the opportunity to consider the demonstration of heroism within the tragedy.

NOTES

1. Hulleah J. Tsinhnahjinnie, "When is a Photograph Worth a Thousand Words?" in *Photography's Other Histories,* eds. Christopher Pinney and Nicolas Peterson (Durham, NC: Duke University Press, 2003), 45–46.

2. Richard E. Jensen, R. Eli Paul, and John E. Carter, eds. *Eyewitness at Wounded Knee* (Lincoln: University of Nebraska Press, 1991), 110.

3. John E. Carter, "Making Pictures for a News-Hungry Nation," in *Eyewitness at Wounded Knee,* 40.

4. Robert Venables, "Looking Back at Wounded Knee 1890," *Northeast Indian Quarterly* (Cornell University American Indian Program) 7, no. 1 (Spring 1990): 37.

5. Quoted in Venables, "Looking Back at Wounded Knee 1890," 37.

6. Venables, "Looking Back at Wounded Knee 1890," 37.

7. Jerzy Grotowski, *Towards a Poor Theatre* (New York: Simon and Schuster, 1968), 211–18.

8. James Forsythe, "The Plains Cree Grotowski," *The Canadian Journal of Native Studies* 11, no. 2 (2001): 355–66.

9. Ibid., 358.

10. I decided not to include a reproduction of this image as a reference for this article because I believe that to replicate it again is to participate in a destructive process. The image is readily available in books on the topic as well as online.

11. Conversation with the artist, October 4, 2005.

12. Maria Yellow Horse Brave Heart and Lemyra M. DeBruyn, "The American Indian Holocaust: Healing Historical Unresolved Grief," *American Indian and Alaska Native Mental Health Research* 8, no. 2 (1998): 66. Available online at http://aianp.uchsc.edu/ncaianmhr/journal/pdf_files/8(2).pdf.

13. Roger Ebert, review of *Billy Jack,* in *Chicago Sun Times,* August 2, 1971.

14. Forsythe, "The Plains Cree Grotowski," 360.

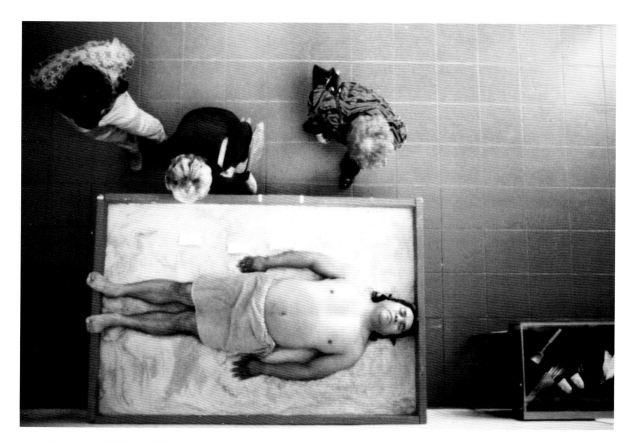

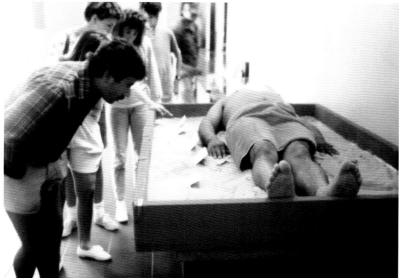

FIG. 17/18 *THE ARTIFACT PIECE*, 1987, JAMES LUNA

PERFORMANCE AT THE SUSHI GALLERY, SAN DIEGO MUSEUM OF MAN, SAN DIEGO, CA

THE ARTIFACT PIECE AND ARTIFACT PIECE, REVISITED

Lara M. Evans

In early April 2008, artist Erica Lord climbed into a museum display case for a reenactment of *The Artifact Piece,* a performance artwork originally created and performed by Luiseño artist James Luna. The initial performance of the work by Luna took place in 1987 at the San Diego Museum of Man (FIG. 17 and 18). There, Luna placed himself on display in a museum case, accompanied by additional display cases that contained a selection of his important personal items. The piece startled visitors who came to the exhibit expecting a customary anthropological display of the artifacts of a long-gone primitive people. The presence of a live Indian on display punctured the romantic fantasy of the vanishing race. *The Artifact Piece* had such impact that it is now one of the most well-known and important performance artworks by a Native American artist. It also helped shift museum display practices for Native American material and the concept of the cultural "other" in the late 1980s and early 1990s. *The Artifact Piece* established the beginning of Luna's literal "body" of performative work, and also, along with Guillermo Gómez-Peña and Coco Fusco's *Two Undiscovered AmerIndians* (1992) and Jimmie Durham's *On Loan from the Museum of the American Indian* (1985),[1] was part of a wave of indigenous peoples talking back to the institutions that have represented them to non-indigenous audiences. In these artworks, the subjects of anthropology (also the objects of institutionalized collection) speak back to those academic disciplines, patriarchal

64

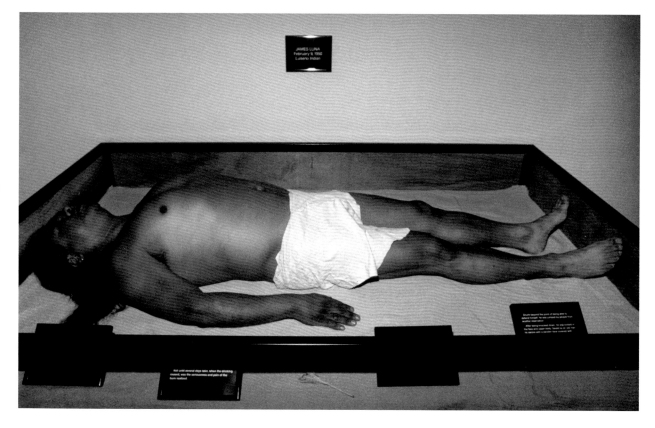

institutions, and legislative bodies that circumscribe Native sovereignty and operate in disregard of existing Native epistemologies.

James Luna's second performance of *The Artifact Piece* took place as part of *The Decade Show* in 1990 (FIG. 19).[2] In both iterations of the work, Luna created a performance/installation artwork that emulated the customary display techniques used for anthropological museum displays of "primitive" peoples. Luna placed his body on display by lying on a large sand-covered display table wearing a loincloth. Didactic labels provided detailed information about the "American Indian" on display: an accounting of scars, medical diagnoses, and biographical information written in the third person. Luna's *The Artifact Piece* invited museumgoers to view his Indian body as an artifact, a preserved specimen or anthropological replica, in order to startle viewers when they read the labels that described/explained the bodily scars in a way that dismantled the aura of the historic. For example, one label read: "Having been married less than two years, the sharing of emotional scars from alcoholic family backgrounds was cause for fears of giving, communicating, and mistrust. Skin callous on ring finger remains, along with assorted painful and happy memories."[3] Two vitrines displayed the possessions of this "authentic" Indian. Objects in the display cases individualized Luna by presenting audiences with his own artifacts, including his favorite albums and other objects of popular culture, plus diplomas, divorce papers, childhood photos,[4] and other "cultural artifacts" such as a beaded medicine bag, moccasins, toys, and favorite books and records (Kerouac and Ginsberg, Sex Pistols and Hank Williams). Upon close observation of the Indian body on display, the viewer who took the display as an anthropological specimen of the phenotypical Indian was startled to find the display to be alive. Museumgoers approached the display as though it were just another exhibition in the museum, not realizing they were examining a living person until they happened to observe the rise and fall of Luna's chest with his breath. Some visitors even walked past

FIG. 20 JAMES LUNA POSED IN FRONT OF
AN IMAGE OF HIS PERFORMANCE PIECE
THE ARTIFACT PIECE

IN THE "OUR LIVES" SECTION OF THE MALL MUSEUM
OF THE NATIONAL MUSEUM OF THE AMERICAN INDIAN,
JANUARY 28, 2005

him without realizing there was a person there. Critic Elizabeth Hess observed that "the realization that Luna was not an inanimate object was stunning. Who was watching whom? . . . What would he do if I talked to him? Touched him? I felt self-conscious staring at Luna, yet I was riveted."[5]

The artwork remained effective even without the bodily presence of the artist. The displayed objects were able to function independently of Luna's presence, and the impression of Luna's body in the sand was an indexical sign of his previous occupation of the space. In his absence, the labels described the now invisible, imagined body of the missing/disappeared Indian. His scars and other bodily particulars hung suspended in the visitor's imagination. The museum's Indian had climbed down from the display and walked away, leaving his Hank Williams and Sex Pistols records behind.

Even though *The Artifact Piece* first took place more than twenty years ago, it has a continuing presence in writing about contemporary Native art in journals, books, textbooks, and online encyclopedias. Richard West, founding director of the National Museum of the American Indian (NMAI), has said that *The Artifact Piece* "dramatically and forever changed the relationship between Indians and those who visit, study, patronize and in other ways interact with Native peoples."[6] NMAI installed a large photograph of *The Artifact Piece* at its museum on Washington's mall,

and even though it is only a photograph, it gets interesting responses (FIG. 20). Kids ask, "Why is there a picture of a dead body?" and "Why is he an artifact?"[7] It is an invaluable starting point for the sticky issues that the Native-designed exhibits raise for museumgoers accustomed to conventional representations, particularly in a Smithsonian Institution museum that Americans generally perceive as a "celebratory institution."[8] The photograph serves as a placeholder and a reminder. It is a tangible means of introducing and keeping the memory of a pivotal moment in the public mind.

Erica Lord's April 2008 reenactment, titled *Artifact Piece, Revisited*, brings the work out of the textual and photo-documentation realm of the recent past and back to the possibilities of the physically present moment. The significance of bringing some live version of *The Artifact Piece* back into a museum environment comes from several intersecting factors: experiential transmission of knowledge, the embodiment of memory, and visual sovereignty. As Susan A. Crane observed in her essay "Memory, Distortion, and History in the Museum,"

> *Visits to museums—whether of history, art, ethnography, or technology—are ordinary, everyday events in modern western societies; they place museums within the living memory of many people, the majority of whom do not consider themselves professionally responsible for the contents or existence of the museum, much less for historical memory.*[9]

Luna's performance of *The Artifact Piece* at the San Diego Museum of Man collapsed historical memory and living memory in a jarring moment of realization for an unsuspecting public. The display practices used in *The Artifact Piece* and the surrounding exhibits provided authoritative historicity, and the mix of contemporary objects and the actual living Indian on display transferred viewers into the realm of living memory, making viewers suddenly feel a degree of responsibility for their role as

viewers and constructors of historical memory through their uncritical consumption of museum practices.

Like Dada artist Marcel Duchamp with his readymades, Luna created a work that critiques the power of the museum to represent authority, taste, aesthetics, and cultural value.[10] Of course, Duchamp was commenting specifically on *art* museums. Luna began with *The Artifact Piece* in an anthropological museum: the San Diego Museum of Man, and later performed it within a "fine art" museum environment, at New York City's Studio Museum in Harlem as part of *The Decade Show* in 1990. In an art museum, particularly as part of an exhibition of contemporary work that included a number of performance artworks, this second performance must be understood as a form of "quoting" the original performance. Removed from the anthropological museum surroundings, *The Artifact Piece* became a critique of anthropological display relocated to an art museum. Rather than re-creating the initial performance, the performance at *The Decade Show* could be described with the mathematical term "successive approximation." A successive approximation is a problem-solving, computational method "in which a succession of approximations, each building on the one preceding, is used to achieve a desired degree of accuracy."[11] Of course, we are not talking about a situation that involves mathematical accuracy, but social, political, and cultural relevance. Today, a little more than twenty years after its first appearance, *The Artifact Piece* has continued to be relevant if one judges by textual references and reproductions of photographic documentation. While academic scholarship highly privileges the written form of continued relevance, there are additional means by which to judge an artwork's continued relevance, for example, references to the original work in new work by other artists.

This impulse to repeat earlier performance artworks is something that is happening to some degree in the performance art movement as a whole. Marina Abramovíc performed a series of performance works

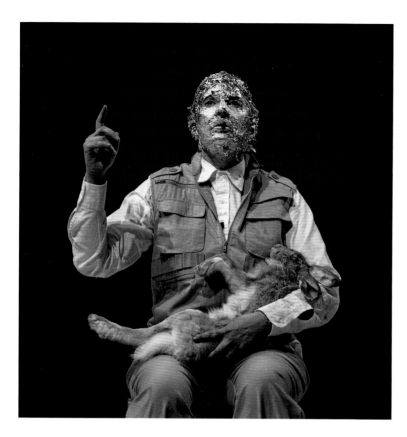

FIG. 21 MARINA ABRAMOVÍC
PERFORMING JOSEPH BEUYS'S
HOW TO EXPLAIN PICTURES TO
A DEAD HARE (1965)

AT THE SOLOMON R. GUGGENHEIM MUSEUM,
NEW YORK, NY, NOVEMBER 13, 2005, AS PART OF
SEVEN EASY PIECES

titled *Seven Easy Pieces* in 2005. The work was executed at the Guggen-
heim Museum, and Abramovíc reperformed works originally done by Vito
Acconci, Bruce Nauman, Gina Pane, Joseph Beuys, and Valie Export, and
re-created her own *Lips of Thomas* from 1975 (FIG. 21).[12] Yoko Ono redid
Cut Piece in 2003 and changed it substantially. While three occasions
may not make an overwhelming trend, they show that Lord's impulse to
re-create a previous performance artwork is not an isolated event. "In
'Critically Queer,' feminist theorist Judith Butler says that performative
actions only succeed if they have accumulated 'the force of authority
through the repetition or citation of a prior, authoritative set of prac-
tices.'"[13] The field of performance art may be approaching a point where
previous artworks can both lend and gain authority through repetition and
citation. However, it is not only in the realm of performance theory that
such performative practices can gain significance. In Hulleah Tsinhnahjin-
nie's recent essay titled "Visual Sovereignty: A Continuous Aboriginal/
Indigenous Landscape," she makes a call for the practice of "visual sov-
ereignty," which she defines as "the landscape that exists within the
intellectual spherical confederacies of the global Aboriginal/Indigenous

thought, pain, beads, beauty, petroglyphs, weaving, technology and action, all without apology . . . It is a landscape where young indigenous artists create visions of continuance and senior artists breathe a sigh of relief."[14] Maybe Luna is not ready to breathe a sigh of relief, but the successive approximations of *The Artifact Piece* may lead us to new theoretical ground—or at least new theoretical ground in the Western lexicon. Performativity has long held validity in indigenous cultures. Performance artwork can potentially be viewed as occurring along a spectrum of indigenous performative activities that have continuously acted as a valid means by which to accomplish multiple purposes: for the reliable transmission of knowledge, as internal social activism, and for reification of esteemed cultural values. In other words, performative acts are not for entertainment purposes, but are serious social, intellectual, and even spiritual acts that function in very complex ways. In some respects, they may dismantle or critique failings in society, uncover injustices, etc., but performative works can also work to build, rebuild, and theorize new possibilities. Even as indigenous peoples in the Americas have been indoctrinated into text-based knowledge transmission as the form preferred by colonizing forces, performative knowledge transmission has continued as a crucial element of cultural and personal survival. I would propose that Lord's revisiting *The Artifact Piece* is within the intellectual confederacy of global Aboriginal/indigenous thought and is part of the visual sovereignty that relies upon a form of continuance that is not static, but is instead part of a long trajectory that is normative for many non-Western cultures and which might be described in Western lexicon as successive approximation. Of course, an "approximation" never gets you to any particular point, but when a hoop describes existence better than a straight line and an end-point signifies genocide, a successive approximation is clearly preferable to "termination."

*E*rica Lord's artwork in general is about issues of gender and hybridity, locale, and the transfer of traditions into new modes and new environments. She usually works in photography and multimedia installation. Her works include performative elements, though the spectator is usually a camera rather than a live audience. Luna and Lord had seen each other's work before and were able to set up a meeting in the summer of 2007. Lord had long wanted to talk to Luna about *The Artifact Piece*; when she was an undergraduate, Lord had staged her own version of *The Artifact Piece* in fulfillment of a class assignment to "redo" someone else's performance art. Years had gone by; Lord earned her MFA and then embarked on her career as an artist and professor. Now she wanted to do *The Artifact Piece* for real, and for that, she needed Luna's permission and approval. During their meeting, they discussed Luna's experiences performing *The Artifact Piece,* including the physical challenge of lying still for extended periods of time. Both artists were enthused about the possibilities for new meanings to arise from Lord's revisiting of *The Artifact Piece*. All that was needed was a place to perform the work. An opportunity to do so arose at the National Museum of the American Indian's George Gustav Heye Center in New York, with Paul Chaat Smith curating the performance event.

In the months before the April 2008 performance, I was intrigued by the uncertainties I had about how audiences would react to the work. Would issues of gender trump issues of race? Would criticisms of museum display practices get lost in the mix? Would issues of cultural patrimony and repatriation fall by the wayside compared to the objectification of a young female mixed-race body on display? Would Lord even be seen as Indian? As often happens when anticipating an event, the questions one dreams up ahead of time may not be the ones that dominate public discussion. In my case, I was not expecting to hear people question over and over why anyone would redo *The Artifact Piece*. Some people I spoke with ahead of time dismissed the piece as

derivative. It is not really possible to replicate the original surprise that the first performance at the San Diego Museum of Man possessed. Audience reaction is understood as an important aspect of the success of the first occurrence of Luna's performance of *The Artifact Piece*. If the piece depended upon surprise and novelty, however, then Luna's subsequent performance of the work at *The Decade Show* would have been a failure, and this is not the case. Negative reactions to the restaging of *The Artifact Piece* by another artist must have some additional source. I think much of the dismissive impulse comes from the insidious hunger in the mainstream art world for the radically new. The constant pressure to create something entirely different from anything that has come before sacrifices the potential for artists and audiences to truly explore a subject. A hunger for rupture blinds us to dynamic subtleties. It limits the potential to develop deep understandings of the complexities of art and human experience. To my mind, it seemed clear that while the forms and actions of Lord's *Artifact Piece, Revisited* would be very similar to Luna's original work, Lord's work could not carry precisely the same meanings because of differences in gender, age, and textual specificity. I was particularly concerned about issues of gender. The stereotypical identification of Indian men is readily apparent. Indian women often are not specifically identifiable as Indian to the general public unless they wear Plains-style dress. When you say "Indian," many people automatically assume "male." Additionally, Athabascan and Inuit traditional clothing is not familiar to the general public. Lord's choice of clothing was modeled partly on a female approximation of Luna's loincloth, but was also inspired by two articles of clothing in a museum collection that were labeled "Eskimo Bikini—Male" and "Eskimo Bikini—Female" (FIG. 22).[15] A long-haired brown man in a loincloth is recognizable as an "Indian." Female Indian-ness is much less recognizable, as the category of woman tends to be folded into the consumer culture assumption that women are objects of desire. Cultural specificity is erased in the face of

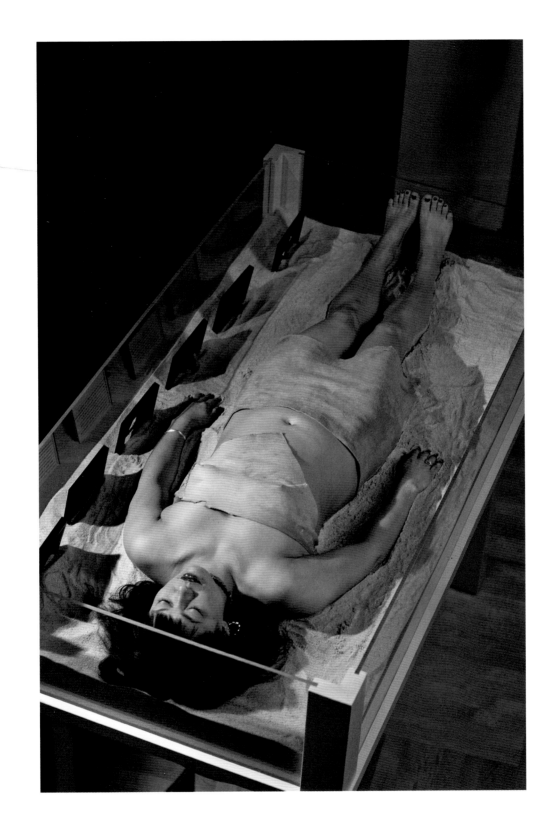

sexualization. The *olla* maiden from the Southwest, the Land O'Lakes maiden from the butter package, the women in Edward Curtis's photographs, and Disney's Pocahontas are the most common images of Indian women. Go into any tourist shop in the Southwest and you will find rack after rack of postcards of historic photographs of serious-looking Indians, mostly men, with a few women and small children thrown in. Regional differences in material culture and the degree of public familiarity with clothing types would also have an impact on the meaning of the new work. For example, a museum audience in Alaska is likely to be at least somewhat familiar with the Native Alaskan material culture on display as part of Lord's performance—more so than an audience in New York City.

When the time came for *Artifact Piece, Revisited* to be exhibited in New York, I flew in the night before and met Lord the next day at NMAI's Heye Center, where she and the museum staff were setting up in the Diker Pavilion, a performance and exhibition space in the lowest level of the museum (FIG. 23). Display cases inset in the walls of the room contained an exhibition titled *Beauty Surrounds Us*.

The museum crafted three display cases specifically for *Artifact Piece, Revisited*. The largest case was sized to allow Lord to lie down in it. The wooden framework held Plexiglas sides, and the bottom of the case was layered with fine-grained white sand. The height of the table was taller than the case used by Luna and required that Lord use a stepladder to climb in and out of the display. The other two display cases were square pedestals topped by Plexiglas covers and filled with Lord's personal belongings. The lighting in the room was dim, but bright pools of light illuminated the components of *Artifact Piece, Revisited*. When museum visitors entered the space, they were drawn to the illuminated displays

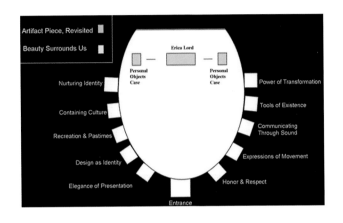

FIG. 23 *ARTIFACT PIECE, REVISITED*

EXHIBIT LAYOUT RENDERING

at the center of the far end of the oval room. The powerful effect of the lighting and spatial arrangement led viewers straight to the display case where Lord was lying in absolute stillness. Then, people began reading the signs in and between the cases. There was quite a lot of text involved in Lord's version—much more than in Luna's. And yet viewers tended to spend a great deal of time reading the texts, examining the objects in the cases, and looking at Lord's motionless body (FIG. 24).

FIG. 24 *ARTIFACT PIECE, REVISITED*, 2008, ERICA LORD

PERFORMANCE AT THE NATIONAL MUSEUM OF THE AMERICAN INDIAN'S
GEORGE GUSTAV HEYE CENTER, NEW YORK, NY

Lord used two stanchions with didactic texts in addition to the placards set on the sand in her main display case. One of the stanchions provided a map labeled "Alaska's Native Languages and Cultures" along with the following texts:

ATHABASCAN INDIANS
The Athabascan people traditionally come from Interior Alaska, an expansive region that begins south of the Brooks Mountain Range and continues down to the Kenai Peninsula. There are eleven linguistic groups of Athabascans in Alaska. Athabascan people have traditionally lived along five major river ways: the Yukon, the Tanana, the Susitna, the Kuskokwim, and the Copper river drainages. For much of history, Athabascans were highly nomadic, traveling in small groups to fish, hunt, and trap. Today, the Athabascan people live throughout Alaska and the Lower 48 states, returning to their home territories to harvest traditional resources. The Athabascan people call themselves "Dena," or "the people." In traditional and contemporary practices Athabascans are taught respect for all living things. The most important part of Athabascan subsistence living is sharing. All hunters are part of a kin-based network in which they are expected to follow traditional customs for sharing in the community.

SPECIES: HOMO SAPIENS
NAME: *ERICA LINNÉ LORD*
B. 1978, FAIRBANKS, ALASKA
This specimen originates from the village of Nenana, located in the central area of Interior Alaska. Her given name is Erica, and she is 30 years old. Her blue eyes and skin color are comparatively lighter

than other Athabascans, however she does have shovel-shaped incisors, a unique characteristic amongst many Asian and Native peoples. Her surname, Lord, is an English name, a testimony to intermarriage within her family and an example of a growing tradition among indigenous people. Her racial/ethnic background is understood to be mixed-blood stemming from Athabascan, Iñupiaq, Finnish, Swedish, Japanese, and English roots. Iñupiaq people are an Inuit tribe who live in regions north of Athabascan territory. Though it is common practice today, miscegenation between Athabascans and Iñupiaqs used to be rare and often discouraged.

Lord consciously sought to use anthropological and classificatory language for this signage. She wrote the text during an artist's fellowship at the School for Advanced Research in Santa Fe, New Mexico, and consulted with staff anthropologists regarding text for the labels. Lord created a set of texts intentionally full of contradictions, with competing tensions around hybridity, cultural specificity, classification of boundaries, and transgressions against those classifications. Lord resists pressure to identify a singular ethnic or racial category, particularly the "two worlds" binary opposition of white vs. Indian. She complicates the monolithic assumptions of whiteness by specifying Finnish, English, and Swedish origins. "Miscegenation" is a loaded term, associated with resistance to interracial marriage. Instead of using the term to refer to relations between white and Indian, Lord uses it to refer to a combination between two indigenous cultural groups: Athabascans and Iñupiaqs. She removes whiteness from the center. In her book *Radical Gestures: Feminism and Performance Art in North America,* Jayne Wark describes ironic displacements in feminist work from the 1970s and '80s as a strategy to deal with what literary theorist Coral Ann Howells has called the "colonized mentality where one's self-image is split between imposed

traditional patterns and authentic experience."[16] Such an analysis is difficult to apply to Lord's work because she is working under conditions where multiple traditional patterns apply. This type of feminist reading assumes a monolithic white patriarchal tradition as the *only* tradition. There is also an unspoken assumption that traditions are negative, which is certainly problematic for indigenous artists. Native artists are under pressure to identify primarily as Indian or white, or to at least use the language of "walking in two worlds." Instead, Lord's text and selection of objects uses ironic displacement to unify authentic experiences from multiple traditional patterns, some of which are resisted and others embraced. Lord makes a claim for varied, but not fragmented self-image—a commingled collection of objects in shared space.

As in Luna's *The Artifact Piece,* Lord uses two display cases of personal objects to complicate assumptions about what constitutes a display of Indian "artifacts." One case displays her regalia[17] and family photographs. In the other, Lord gathers favorite books, more photos of family and friends, CDs, DVDs, paper documents, and articles of clothing, some of which signify Indian identity and some of which do not (FIG. 25).[18] The objects position her identity in relationship to alternative music, hip-hop culture, and film, in addition to contemporary Native music and art. She also includes objects that refer to her previous bodies of work, such as earrings and a wig used in her *Un/Defined Self-Portraits* series and her Polaroid camera. The catalog for Luna's exhibition *Emendatio,* which was then on display upstairs from Lord's performance space, is included as an homage. Another important object in this display case is a copy of Barack Obama's book *Dreams from My Father: A Story of Race and Inheritance.* Obama's mixed-race heritage was much in the news at the time, and inclusion of the book not only reflects the artist's personal interests but draws connections between African American and Native American experiences in multiracial families. Looking back on my experience as part of the audience for this performance, the presence

of this particular book seemed to successfully tie all the other objects together into a cohesive whole and related the piece overall to events in national politics. I was in the gallery for seven hours on the first day of the performance and overheard many interesting comments and questions from the audience. One man had to repeatedly be told that he could not photograph the artist. Museum staff informed him that she was alive and did not want to be photographed, yet he persisted in raising his camera. The close presence of a museum guard seemed to be a necessity at that point. Later, a pair of viewers wanted to know if the museum has a list of Indians who volunteer to be put on display on a regular basis. One of the more interesting shifts in people's behavior in the gallery during Lord's performance was a very subtle one. In the hours preceding the performance, the regular exhibition installed in the Diker Pavilion was looked at only very briefly by visitors to the space. During the performance, viewers were drawn to *Artifact Piece, Revisited,* where they closely examined the objects, labels, and the body of the artist. Afterward, many viewers turned to view the exhibition *Beauty Surrounds Us,* installed against the curving walls of the room. Instead of quickly cruising by the cases, as usually happens, people paused for extended periods and really examined the objects in that exhibition as well. I think that the way that Lord's objects on display were clearly personalized and symbolized her identity as a person created a shift in how people viewed the other objects in the room. I, too, was conscious of a shift in thinking of *Beauty Surrounds Us* as a collection of historical objects to thinking of them as a person's precious belongings. Strangely, the dehumanizing display of the body of the artist as an object had the effect of humanizing objects on display that were not even part of the performance event.

Discussion of gender, masculinity, and manliness in relationship to Luna's *The Artifact Piece* was nonexistent in the late 1980s. Substituting a female body creates a drastic shift in perception, however. A sense

81

of sexualized voyeurism is inescapable. Additionally, bodily ornamentation, including jewelry, tattoos, and makeup have an effect on the meaning of *Artifact Piece, Revisited*. I heard from some viewers that they did not like the fact that Lord wore makeup while she was on display. I found these comments intriguing for what they said about the artist's choices. Would it have been better if she had not worn makeup? Would she have better fit our notions of what constitutes "natural" beauty? Would the lack of makeup make her seem historically correct? Frozen in time? Authentic? Obviously, that was not Lord's goal with the work overall. Wearing makeup further sexualized her and made her subject to assumptions about beauty and fashion. She was damned one way or the other. Luna never had to consider the question of whether or not he should wear makeup. Lord had to decide which set of meanings to court by her aesthetic choices. In the end, she followed a normal routine. She's going out in public. She will be looked at; therefore, she wears makeup. Lord also referenced bodily adornment, including her nail polish, in the labels set in the sand around her body. She anthropologizes the normal contemporary practices of female adornment. As a woman viewing the work, I was suddenly self-conscious of the meanings of my own jewelry, makeup, and fashion choices. I think it was a smart choice and led other female viewers to identify with Lord as a woman, rather than identify her solely as an "Indian" other, which could potentially happen while present in a museum that focuses on Native American material culture.

After seeing photographs of an early mock-up of Erica Lord's *Artifact Piece, Revisited,* I was struck by the aesthetic relations with memento mori, wakes, and burials. The photographer's framing of the scene unconsciously mimicked these codified scenes of mourning. The prone position is not the usual museum display practice—manikins stand in upright postures and sculpted figures inhabit dioramas where they have been halted in mid-task, as though captured by a photograph. Other times, clothing is mounted upright with an invisible but implied human

body beneath the garments. The vertical display is much more common than a horizontal display, except when the display is of actual human remains, as in the case of mummified human remains from Egypt or Peru. The choice of a prone position by Luna and Lord could partially be a matter of practicality; it is easier to lie still than it is to stand still for long periods of time. However, the prone position subconsciously ties the politics of display with the history of genocide. The placement of the cases and the arrangement of chairs in rows in front of *Artifact Piece, Revisited* made the installation even more closely resemble a wake, the display of the body of the deceased that may occur as part of a funeral service. The chairs were actually present in order to accommodate an audience for a public talk by the curator and the artist at the close of the first day's performance. The changes in the space and lighting and the presence of audience seating proved to be significant differences from Luna's *The Artifact Piece,* both in terms of aesthetics and meaning.

In Jean Fisher's 1992 article "In Search of the 'Inauthentic': Disturbing Signs in Contemporary Native American Art," Fisher uses the writings of Fritz Fanon and Homi Bhabha to compare and contrast the dynamics produced by colonialism in India and in America. She makes some important distinctions:

> *Repression of Native American difference differs from that of India under British rule, which infiltrated an existent hierarchical Indian Society with a civil and legal organization administered by a subaltern class schooled in the "British way of life." But the introject gaze of United States colonialism stages the Native American not as the "partial presence" of Bhabha's mimic man of the British Raj, but as a disappearance; he is not "almost the same but not quite"; rather, he is not there at all. He has vanished, later to be mourned and resurrected through a constant return to the signs of his once-having-been-there.*[19]

Symbolically, the positioning of the Indian bodies in both versions of *The Artifact Piece* implies that museum collections are complicit in the attempted, but failed, genocide against Native peoples. Lord's interpretation truly turns the piece into a mourning and resurrection. When Lord was not on display, a label with the following text was placed in the hollow her body formed in the sand: "This item has been temporarily removed for further research leading to possible repatriation." It is standard practice for museums to replace objects temporarily off exhibit with a label, so in this way Lord is integrating museum practice into her performance.

"Repatriation" is a reference to the Native American Graves Protection and Repatriation Act of 1990 (NAGPRA). An additional text panel explains NAGPRA, which came into being after Luna performed *The Artifact Piece*. A federal law, NAGPRA was written to provide a way for tribes in the United States to file claims for the return of human remains in certain cultural institutions back to their communities of origin. It also set down rules regarding required actions when excavations turn up human remains. In spite of the legislation, there are still human remains and burial objects in museum and government collections that have not been returned to their tribes. Some institutions have been proactive and have built strong relationships with tribal communities. NMAI, which as part of the Smithsonian Institution is not subject to NAGPRA, has its own repatriation policy and has worked to return human remains internationally.[20] In other instances, an institution can continue to hold such materials at the preference of the tribe.

Of course, a museum hosting *Artifact Piece, Revisited* would have to have some confidence in its own record with regard to repatriation, and indeed, in its ability to weather any criticism of its other exhibits that might arise from a shift in perceptions among museumgoers. Such criticism may be beneficial, particularly if it leads to donors willing to help fund the redesign of outmoded exhibitions. It is a problem when it is

possible for museumgoers to leave an exhibition about Native peoples thinking that Indians only existed in the past. *Artifact Piece, Revisited* pierces romantic fantasy and alters museumgoers' perception of the other exhibits. A possible future location for *Artifact Piece, Revisited* is the University of Alaska Museum of the North in Fairbanks. While details of this future performance are still under discussion, Lord's performance could take place just outside the museum's Gallery of Alaska, which includes a display of an Athabascan dress that Lord believes once belonged to her family. The performance in Fairbanks would also be symbolically important for Lord because it is roughly an hour's drive from her home village of Nenana—about the same distance as the San Diego Museum of Man from Luna's La Jolla reservation. In both instances, the artist's home community is largely invisible and experientially remote from the museum's customary visitors.

*L*una's original performances of *The Artifact Piece* humanized and individualized himself as an Indian while also critiquing museum display practices in regard to the "other." Lord does more than "revisit" the piece; she brings hybridity, sexualized objectification, the trap of beauty, and tribal specificity to the work. Luna's *The Artifact Piece* was designed for an unsuspecting audience. Lord decided that her version would not be unannounced. She created an opportunity for a generation of artists and viewers who had read about *The Artifact Piece* and seen the photographic documentation to take part in the formation of *The Artifact Piece* as a continuing legacy, as a meaningful repetition that carries with it references to the first performance of *The Artifact Piece* but that brings out additional nuances: gender, regionalism, and the fluid interplay between American pop culture and contemporary Native youth culture.

NOTES

1. Jean Fisher, "In Search of the 'Inauthentic': Disturbing Signs in Contemporary Native American Art," *Art Journal* 51, no. 3 (Fall 1992): 47.

2. *The Decade Show: Frameworks of Identity in the 1980s* was a collaboration among the New Museum of Contemporary Art, the Museum of Contemporary Hispanic Art, and the Studio Museum in Harlem.

3. Paul Chaat Smith, "Luna Remembers," in *James Luna: Emendatio,* Truman Lowe and Paul Chaat Smith, curators (Washington, DC: National Museum of the American Indian, Smithsonian Institution, 2005), 34.

4. Charlotte Townsend-Gault, "James Luna," in *Land, Spirit, Power: First Nations at the National Gallery of Canada,* eds. Diana Nemiroff, Robert Houle, and Charlotte Townsend-Gault (Ottawa: National Gallery of Canada, 1992), 192.

5. Elizabeth Hess, "The Decade Show: Breaking and Entering," *Village Voice,* June 5, 1990, 87–88.

6. W. Richard West, Jr., "Lunar Exploration," in *James Luna: Emendatio,* 7.

7. Personal communication, July 17, 2007.

8. Richard Kohn, "History and the Culture Wars: The Case of the Smithsonian Institution's Enola Gay Exhibit," *Journal of American History* 82 (1995): 1,038. Cited in Susan A. Crane, "Memory, Distortion, and History in the Museum," *History and Theory* 36, no. 4 (December 1997): 59.

9. Crane, "Memory, Distortion, and History," 46.

10. In using the term "cultural value," I refer both to monetary value assigned to objects of material culture and to the implications of cultural authenticity.

11. For a definition of successive approximation, see, for example, http://dictionary.reference.com/browse/successive +approximation. Last accessed February 4, 2009.

12. Jennifer Blessing, "*Seven Easy Pieces,*" in *Performa: New Visual Art Performance,* by RoseLee Goldberg (New York: Performa, 2005), 116–21.

13. Judith Butler, "Critically Queer," in *Playing with Fire: Queer Politics, Queer Theories,* ed. Shane Phelan (London: Routledge, 1997), 13. Original source of the quote from Butler is "Critically Queer," *GLQ* 1 (1993): 19. Original emphasis.

14. Hulleah Tsinhnahjinnie, "Visual Sovereignty: A Continuous Aboriginal/Indigenous Landscape," in *Diversity and Dialogue: The Eiteljorg Fellowship for Native American Fine Art,* 2007, ed. James H. Nottage (Seattle: University of Washington Press, 2007), 15.

15. Personal communication, September 18, 2007.

16. Jayne Wark, *Radical Gestures: Feminism and Performance Art in North America* (Montreal: McGill-Queen's University Press, 2006), 93. The quote is originally from *Private and Fictional Words: Canadian Women Novelists of the 1970s and 1980s,* by Coral Ann Howells (London: Metheun, 1987), 184.

17. I use the term regalia to refer to specialized ceremonial and "traditional" clothing. Regalia contains coded information in materials, method of construction, and embellishment that indicate tribal affiliation, familial lineage, intermarriages, and spiritual and mythological affiliations. Lord included her beaded hide dress, gauntlets, moccasins, etc.

18. James Luna's first performance of *The Artifact Piece* at the San Diego Museum of Man actually used three cases plus the case in which he displayed himself. Another case held personal objects, a second case held what Luna termed "medicine objects," and the third case contained *Indian Moccasins,* a small collection of shoes that Luna had altered. For example, a pair of cross-trainers had acorns attached to the soles of the shoes. For *The Decade Show,* he omitted this additional display case because he felt *The Artifact Piece* was stronger without it. (Personal communication, July 17, 2007).

19. Fisher, "In Search of the 'Inauthentic,'" 46.

20. Passed in 1990, NAGPRA applies to federal agencies and institutions that receive federal funding and provides a means for tribes to make claims for the return of certain cultural items (funerary objects, sacred objects, and objects of cultural patrimony) and human remains. The law specifically exempts the Smithsonian Institution from its provisions. Repatriation from the NMAI is addressed in the National Museum of the American Indian Act Amendments of 1996 (Public Law 104–278; NMAI Act was Public Law 101–185, passed November 28, 1989), which cites NAGPRA as minimum standards. The museums within the Smithsonian developed their own process to implement repatriation. For full language of the NMAI Act, see http://anthropology.si.edu/repatriation/pdf/nmai_act.pdf. A good basic reference to NAGPRA is *Mending the Circle: A Native American Repatriation Guide: Understanding and Implementing NAGPRA and the Official Smithsonian and other Repatriation Policies* (New York: American Indian Ritual Object Repatriation Foundation, 1996, rev. 1997).

FIG. 26 **FOUR WAYS**, APRIL 5, 2008, JAMES LUNA

PERFORMANCE AT THE DENVER ART MUSEUM, DENVER, CO

FOUR WAYS
A PERFORMANCE SCRIPT AND THE PROCESS OF CREATING A PERFORMANCE

James Luna

I have maintained over the years that the best way to explain my work is to perform it. For this article I will share my script of *FOUR WAYS,* which I performed at the Denver Art Museum and which offers insight into the themes and the process of developing and performing a performance work. The beauty of performance art is that there is no wrong or right way to develop and present one's work, which means the medium is wide open for exploration. My performance roots come from studio art classes (performance and painting), trial and error, and observing other performance works.

I believe the medium of performance art avails itself to Native culture like no other medium, as one can add traditional forms such as storytelling, dance, singing, and certain ceremonial framework as part of the production. There are not rules but skills that artists need to develop, first and foremost of which is their relationship to their audience.

I will follow a script for *FOUR WAYS* and comment on each scene's actions and purpose.

PRELUDE

I am selective about the prelude music I use to set a mood with my audience. The music may not have a direct connection to the performance, which may be the point of the music. I sometimes add a video for an added visual effect with the music, but again, the video often has nothing to do with the performance but gets the audience to begin thinking and creates anticipation.

In Denver I chose to open the curtain and allow the audience to see the preparation before the performance, which included conversation between the technical crew, the musicians, and myself (FIG. 26). I did my stretching exercises for my body to prepare for the physically strenuous action that occurs when performing. I also wanted to let everyone know that I do get anxious but am in charge of the performance.

I have learned that the audience gives me much power over them, so I feel it is imperative that I use this power from the very beginning to entertain with the elements of surprise, a rollercoaster ride of emotions and for the visual actions I will be performing.

INTRO (ENTRANCE)

I generally choose not to enter with a traditional expected entrance, i.e., an introduction by a speaker followed by opening of the curtains. I may enter from the rear of the space accompanied by selected music and lighting (FIG. 27).

ACTS

In scripting I take care in the sequence of the acts, meaning if I present something humorous, then I can add something serious, political, or perhaps something in a dark mode. My intention is for the audience to not only see and hear the work, but to feel it as well. If I were to present a full performance of the same subject material in the same way, I would lose the interest of my audience, so presenting a range of emotions has worked stronger for me.

BLOCKING

I work from an outline of my script, which is not written word for word as a monologue but has key ideas and key words that I want to cover. On the outline I begin to make notations (blocks) for key areas of the scene. This leads to a refined script that still has the look of an outline.

For each scene I use a "block" sketch so that I can look at it and cover essentials in performing, which are listed below:

Tech: Lights, audio, and video;

Other performers: Their placement on stage and their place in the script;

Music: Sound check, sequence of music;

Props: A selective list of props that will speak to the character or theme of the performance.

I rehearse each work until I feel I know the monologue and actions so that the timing element falls into place. I learned this from Guillermo Gómez-Peña while we were rehearsing one of our collaborations. He noted that I was holding back during my rehearsals. He pointed out to me that if I worked with full force, I would know the piece so well that I would feel free to improvise during the performance. I took his advice, as I found it true, and now rehearse each work until I fully know it.

TECH

In the contract my agent makes clear to the presenter my tech needs such as lighting, audio, and rehearsal time with the tech staff. I have found that early communication with the presenter, by sending a cue sheet and tech rider listing items, eliminates questions that are better worked out in the beginning. Upon arriving for rehearsals I expect key items to be in place, which eliminates dead time that could be better used for refining the performance.

I have noted the best possible scenario for rehearsal and tech, but I also have resigned myself to expect and work with all kinds of conditions. I am not a prima donna but do have key needs that I feel will make the performance successful. There have been instances where I have worked with little or no lighting variation but I inform the audience of these limitations. This banter with them breaks the distance between us and also reminds them that this is a performance. Audio needs are another matter, as my first concern is to be heard, particularly if I am working with live musicians. This calls for extra time devoted to a sound check.

PROPS

I was at one time using many more props, but as I scanned the many things I was beginning to lug around it became apparent that I was getting too theatrical, so I have now reverted to a more minimal approach.

Using a minimal selective process is the same way I choose objects for an installation, which is to say less is more.

OTHER PERFORMERS

I seldom work in collaboration as I like being in full command of works, but I do use audience plants to elicit certain responses from the audience. I also write into the script audience participation, as I don't see myself as an entertainer up on a stage talking down to my audience. When I have the audience join in on some kind of action, I see their excitement at having the opportunity to become a part of the performance. The recent collaboration of working with guitarist Maurice Caldwell I frame as something apart from performance collaboration (FIG. 28). My work with Gómez-Peña is an ongoing project, which I also see as something different, as he seldom chooses to work with just one artist in collaboration, and I have been honored to be that choice.

ACT 1: "TRANSITION"

I introduced this work as having been influenced by seeing Northwest Coast tribal dances. One thing that most impressed me about the dances was the dancers not just putting on costumes and acting like animals but seeing them put on regalia and become the animals. These actions for me are at the heart of my work, as I believe that my concepts and works are a gift that I have been bestowed. Of the animals that I interpret, the actions of Mr. Turtle get the most response as I can contort my face to resemble him (FIG. 29).

ACT 2: "UNCLE JIMMY"

Uncle is a composite of Indian men in my life who influenced my worldview, taught me humility and honesty (FIG. 30). I have to say that there are many contradictions to this character, which makes him a complex individual. Despite the contradictions, Uncle is in charge at all times. This

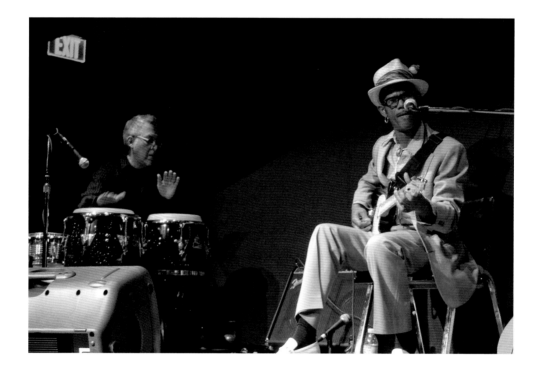

FIG. 28/29/30 *FOUR WAYS*, APRIL 5, 2008, JAMES LUNA

PERFORMANCE AT THE DENVER ART MUSEUM, DENVER, CO

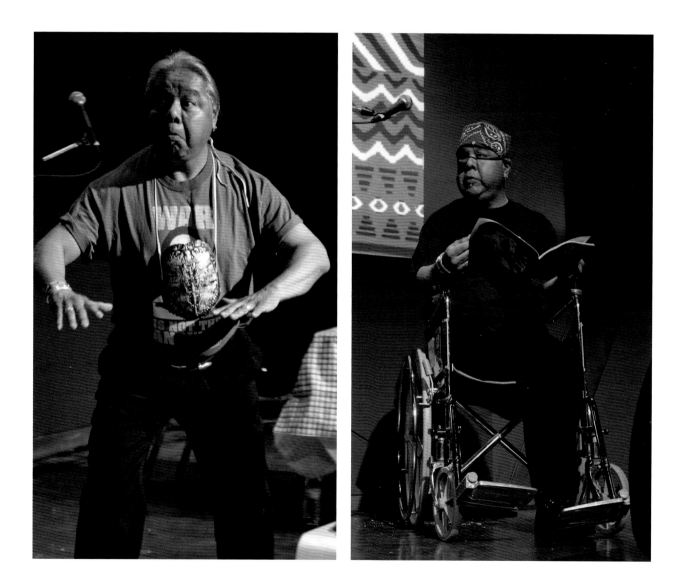

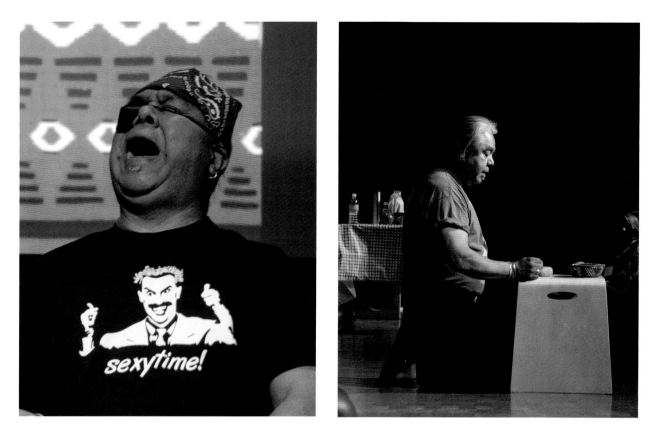

is an emotional work for me as I feel the memories of these men and I have to be focused in performing the work, but there are times I just let go and the character begins to speak on his own (FIG. 31). This may sound a bit strange for some people to understand but is this same issue that I spoke to in "Transition," where I become the character not act it.

It took much effort to decide the look of Uncle Jimmy, as I above all wanted him to represent the reality that we live here on the Rez. Placing him in a wheelchair spoke to the plague of diabetes that is rampant in all Indian communities.

I also wanted to go as far away from the wise old grandpa storytelling Indian that is so prominent in Indian characters in media and pop culture. I added an eye patch to represent another effect of diabetes, which is loss of eyesight. Those simple props created the character's stature, history, and an emotional outlet for me to explore.

FIG. 31/32/33 **FOUR WAYS**, APRIL 5, 2008, JAMES LUNA
PERFORMANCE AT THE DENVER ART MUSEUM, DENVER, CO

ACT 3: "PINK RUSSIAN"

During rehearsal for the Denver performance I was informed that in presenting my planned work, "Cooking Stories," I could not cook, as museum rules did not allow food products near the gallery area (FIG. 32). This put me in the emergency position of having to come up with a piece to fill the void left by exclusion of this work and ultimately rearrange the script. In live performance, one has to be prepared for any kind of miscues, big or small. "Pink Russian" only existed as a photo work, but since there are simple props to the work it was not difficult to reinterpret for the stage (FIG. 33). I had no idea how the essence of the piece would play as a live act. The piece is essentially about the decision to drink alcohol despite health problems. I think this piece was successful in its painful but humorous presentation.

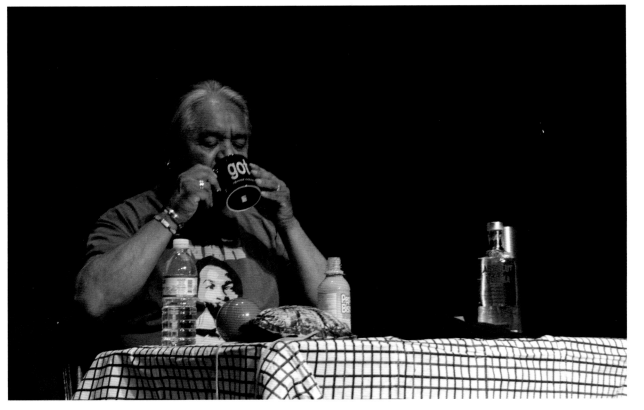

ACT 4: LIVE MUSIC

It has been apparent from the very beginning of my performance career that the audience responded to the selected music I used in my performances. I came to realize that my selection of music was as keen as my process of selection of objects in my installations. I choose music for its complementary color or its distinct cultural difference to performance monologues and scenes.

I came to find younger members of the audience asking titles and artists of music I use, and this taught me that using classic American pop music helped me to bridge cultural and generational gaps. I feel revealing a culture is to understand its music and the cultural activities that are partner to it. In addition to pop music I use traditional and contemporary Native music, but sparingly, as I am cautious not to misuse certain tribal songs that are songs for ceremonial use only.

I decided to put my words to music when it became apparent that this was the right step in my creative process. I understand the excitement generated by live music and the more intent form of listening this generates with the audience. I also found my range of interest in many kinds of pop music provided me with an array of ways for my monologues to become songs. I am currently at a very creative stage with my musical ideas, as working with Maurice Caldwell has opened new doors for me (FIG. 34). Maurice is a versatile guitarist whose stylistic range, from blues to New Age, offers a varied selection to create from. Maurice is also a performance artist in his own right, which makes for an artistic understanding in development of the music composed for performance.

The songs that we perform are songs about Rez life as I see it and possibly how others may not. The song "We Got It All Right Here" is an anthem of pride in our community. The social drinking mentioned is not all bad but acts as a catalyst in sharing a form of contemporary oral tradition. The musical variety has also given me a platform for songs that

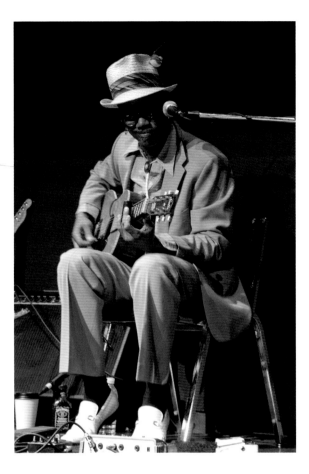

deal with a range of political thoughts, with the music the key to getting the audience's attention. "You Bet" begins with the lament of the Western world's cultural domination then shifts to what I call "Indian logic," which for many Indians are not superstitious notions but truths we live by.

FUTURE PLANS

In May 2008 I retired from my full-time job as a community college academic counselor, a position I held for twenty-two years. It was a great job with somewhat flexible hours, which allowed me to do artwork, but more important with a full salary that allowed me to take risks with my work. I am making the transition slowly, as there is a "ritual" involved with change in lifestyle. I am gradually getting used to not living by the clock. In the process of some current projects I found myself ahead of schedule in completing, shipping, and installing a show, which felt rewarding.

My process for making art is writing, not writing in a traditional sense but writing and accumulating short dated notes. Notes on visual ideas, concepts, and technical problems to be resolved for both performance and installation works. There does not seem to be a shortage of ideas but the trick is where to begin, as there is much to do. Several of the projects I want to address come from my six-month trip to Tokyo. I was fortunate to make friends with Japanese performance artists and got to see and participate in venues in Tokyo. But what I was most impressed and moved by were the Butoh performances I attended. I saw a variety of Butoh styles and was gratified that the dance form went beyond the white-painted body styles that general audiences are accustomed to seeing here in the United States. I witnessed overproduced Butoh that became a spectacle and a current style that features punk rock references. Since that trip I have begun to carefully incorporate aspects of Butoh movements in my performances and my daily exercise, which entails T'ai Chi, weight training, and aerobics. Exercise is an integral part of my life, in part to combat my diabetes and aging.

So there, I said it, I am becoming aware of age and limitations on my body that were not there five years ago. I am aware of what I cannot do and compensate for those movements with more stylized movements such as those in Butoh and T'ai Chi.

I look forward to working with other performers in works that I will write and direct, so the notion of forming a performance ensemble is a likely goal. I had an opportunity to do this for a brief time in a past collaboration and I felt like a painter, which was a great feeling as I was able to utilize my years of experience in a different creative way. When performing I don't get to view myself and go by my feelings and artistic impulses. In the role of director I can manipulate performers to my needs and make adjustments to tech and timing. I have mentioned that I don't have collaboration interests high on my list other than my continuing work with Guillermo Gómez-Peña.

I now have the luxury of devoting more time to my artwork but sometimes I feel there are not enough hours in the day to get done all I need to do, as there are non-art-related projects to do as well, which include writing an essay for an historical book on Pablo Tac, the subject of my Venice Biennale 2005 exhibition; new tech-based minimalist installations; and the newly established James Luna with Intertribal Performance Art Band.

Life is good.

FIG. 35 *ARTIST AND MODEL*, 2003, KENT MONKMAN

ACRYLIC ON CANVAS, 20 × 24 IN.

GYPSIES, TRAMPS, HALF-INDIAN, ALL QUEER, AND CHER
KENT MONKMAN DEFINING INDIGENEITY THROUGH INDIAN SIMULATION AND ACCUMULATION

Tina Majkowski

The lack of serious critical discussion of Native American art outside of its relationship to ethnographic or tribal art and artifacts is one of the biggest problems we artists face . . . Good, risky, original art is being done by Native Americans, and it is this work that must be shown and supported by serious galleries and museums. This art has been developed by individuals educated in the traditions of twentieth-century modernism, but also in touch with their Indian heritage, their cultural differences, and their spiritual concerns. It is deserving of serious critical analysis and it takes no great leap of faith to analyze or appreciate it.

—KAY WALKINGSTICK, "NATIVE AMERICAN ART
IN THE POSTMODERN ERA"[1]

The indian *is a simulation, the absence of natives; the* indian *transposes the real, and the simulation of the real has not referent, memories, or native stories. The* postindian *must waver over the aesthetic ruins of* indian *simulations.*

—GERALD VIZENOR, *FUGITIVE POSES*[2]

Kent Monkman, a filmmaker, illustrator, and visual and performance art-
ist of Canadian Swampy Cree and English/Irish ancestry, appears tired of
the overromanticization of the Canadian landscape in his most recent
installations.[3] By strategically redeploying canonical historical images
that tell stories of European domination and slash-and-burn of North
American indigenous cultures, Monkman works to critique these visual
narratives, or, perhaps more so, he labors to question the veritable accu-
racy of these banal representations of indigenous peoples as noble
savages—as ultimately an already vanished, if not dying, race.[4] Through
his visual reinterpretations of indigeneity, Monkman ultimately interro-
gates and gives voice to the impact of European colonization on indig-
enous forms of sexuality and the transmission of homophobia that
originated from Christian European imperialism. The unspoken lesson
that emerges from this use of the historical image is that even the seem-
ingly fixed nature of history is always in process, subject to alternative
and divergent readings and in need of constant critical vigilance and
reinterpretation. As such, history and performance/art seem more alike
than dissimilar given that both happen in space and time as a process,
rely on spectatorial interaction, and are always open for reevaluation and
revision.

Not unlike his indigenous contemporaries making art from the most
remote Alaskan Yu'pik communities through North America and south
through the Western Hemisphere into the Mapuche territories in Patago-
nia, Argentina,[5] Monkman is seriously invested in performance and art
practices that lend themselves to the creation of a political inquiry into
what constitutes "the Indian" in the collective and various national con-
texts. On one hand this sort of reinvention is always part and parcel of
the artistic process; however, as this theme develops as a prevalent artis-
tic practice among indigenous artists, as a critical and caring audience
we are faced with the question of why this inquiry is particularly urgent
for the indigenous community and how artistic interventions into the

popular visual conception and consumption of the ethnic label "Indian" promote active indigenous communities.

The relationship between political insistence and indigenous performance practices is part of the question of how performance art functions to build and sustain native communities. Ultimately, in tending to this question, I find myself repeatedly drawn to the two epigraphs that begin this essay. Speaking to different quandaries of native representation and written under different native intellectual genealogies, these two voices have continually provided guidance, sustenance, and a critical reminder to keep at this question in favor of any simple and final explication. In fact, it is from a point between these two voices and contentions that I approach this question, which is to say that Vizenor and WalkingStick are something of a critical soundtrack to this essay, and that the fruition of this project is located within the reverberation and interplay between WalkingStick's and Vizenor's edicts.

The queer person of mixed-blood heritage is constantly confronted with the potential mathematical problem of this identity: half Indian, all queer. This is a question of messy fractions. This is a question of how to articulate dual identity markers. This is a question of alterity, or otherness. In "Notes on an Alternative Model—Neither/Nor," Hortense Spillers tells us that alterity describes the "lack of movement in the field of signification [that] seems to be the origin of 'mulatto/a-ness.'"[6] For Spillers, the mulatto/a or half-breed moves within the linguistic field of signification as unarticulated if not inarticulable, faced with the urgent question of whether s/he is white or black. Of course, the history of one-drop rules, blood quantum regulations, and legal and social legislation on the exact parameters of white and non-white is long, tedious, and terrifying.[7] How Spillers instructs us to conceptualize race, however, is—for me—edifyingly resplendent: rather than remain the lowly figure of racial impurity, the poor soul who is unable to answer the question "Are you either black or white?" with safe certainty and is thus torn from

the shores of either whiteness or blackness, Spillers's mulatto/a is the linguistic figure that serves as a wedge between black and white, white and red, and so forth. It seems a simple shift in preposition: either black *or* white to neither black *nor* white. And perhaps it is. However, this picky lexical insistence results in understanding that the half-breed's particular racial quandary speaks volumes about puritanical racial binaries. If the mulatto/a is not *either* black or white but *neither* black nor white, s/he is the linguistic interstice between verifiable and knowable whiteness and blackness and also a sort of wedge into the logic of racial purity.

Although this discussion, for Spillers, is about the racial bind of the half-breed, her overall appraisal that we often find ourselves living in the interstices of identities and experiences opens up this seeming conundrum that the queer half-breed finds himself or herself within. To be sure, this is that question of alterity again. But it is not enough to simply say that we all live within the muck of indeterminacy and the spatiality of the between. For the sake of ideological clarity, where within the field of hybrid racial identity does "queer" fit? Monkman's artistic practice guides us in the pursuit of such an answer. The point between "white" and non-native seems equidistant, a tidy mathematical problem easily solved with the word *half*. Half-breed: half white, half native. Or maybe, as Monkman's aesthetic insistence with the singer/actress Cher—his veritable interlocutor—of half-breedness instructs, half-breed is the demarcation of radical alterity that is unconcerned with knowable blood quantum and neat mathematical divisions that half-Cree, half-non-native, and all-queer earnestly defy. Yes, far from an anomaly in what might be a neat, manageable spatial logic of identity and subjectivity, this notion of the half-breed is indebted to the uneven nature of identity. The uneven crossroads of the half-breed is likewise this place of contact and confluence wherein meanings, identities, and so forth bump up against one another; they intersect and reverberate against and through each other. And it is for this reason that this

positioning of native performance art as within a waver or reverberation is far from a witty rhetorical trick and rather a fortuitous turn.

However, this fortuitous turn circles us back to WalkingStick and Vizenor. I return to these voices precisely because it is all too common in discussions of native art and performance to find oneself ensnared in a conversation about traditional forms of native art. Which in and of itself is not a problem; the problematic aspect lies in the fact that traditional native art is too often seen as the *only* modality of native art production. WalkingStick's concern with the lack of "serious" discussion of Native American art, outside its relationship to ethnography or artifacts, locates this situation as a predicament facing native artists and audiences alike, because "risky," trickier, and, in her words, "original" art is being done by Native Americans and as such is deserving of critical attention. More than fifteen years later, WalkingStick's concern still feels of the moment and emergent. Far from precious academic loitering over definitions and taxonomies, what work gets deemed or categorized as "native art" in current art economies is a pressing issue. The ongoing need for ethnographic authenticity has engendered a climate in which "traditional" native art is often viewed as the totality of Native American art rather than just one mode of native artistic practice. As this happens, not only does native art become overcontextualized, if not reduced to the mere "evidence" of a culture, but also, native artists and audiences alike face the call of further ghettoizing, assimilating, or dividing art markets and art communities. Insofar as the function of criticism is invested with concern rather than condemnation, identifying that there is something askew with how traditional art stands in for the whole body of Native American performance/art is only the first step. The second is attending to how we might think of native performance outside of the call for authenticity.

This task of thinking critically about how to skirt the taxonomical forces of authenticity in the analysis and appraisal of Native American

art is one that I see as indebted to Vizenor's notion of the *indian* as simulation. For Vizenor, the word *indian* can only mark the absence of the Native American. Partially a direct statement regarding the banal fact of the occidental creation of the "Indian," Vizenor's fastidious attention to the very typography of the word "Indian" also tells us that there is something very serious at work in the lexical dyad of *indian* and *postindian*. Highlighted within the title of the text itself, *Fugitive Poses* is an attempt to discuss and potentially alleviate the temporal padlock that continually returns all things native to the pose, or position, of an undisclosed past moment that is radically unable to enter the present moment. Philip Deloria's 2004 publication *Indians in Unexpected Places* likewise takes up this quandary in a more historical manner that renders the question intimately linked to the creation and bolstering of modernity itself. Citing the difficulty of (literally) perceiving the existence of Native Americans in a host of contemporary locales such as beauty salons, and as players instead of mascots of athletic teams, Deloria contends that this is a question of what the expectations are of native people. Simply put, anything that deviates from this narrow expectation is perceived as an anomalous Indian. However, as Deloria painstakingly outlines and archives for us, there is an overwhelming incidence of anomalous Indians; so many that "taken together, it seems to me, the cumulative experiences of such anomalous Indians point to new kinds of questions concerning the turn of the 20th century—perhaps toward a re-imagining of the contours of modernity itself."[8]

Modernity itself is not the concern here; rather, it is how this inability to allow nativeness into the present moment affects Native American art analysis. Of course, this is a concern for the Native American community at large in that this problem of native cultural authenticity is intimately intertwined with the strangeness of continually being compelled to resemble and replicate the terribly banal preconceptions and simulations of Indianness. It is for this reason that Vizenor's steadfast attention

to how these simulations work—and more so, to how to carve out a modality of artistic representation that might, if even briefly, resist these banal preconceptions of nativeness—is of crucial importance in a critical approach to Native American art. Vizenor tells us not only that "the *indian* is a simulation" and "the absence of natives," but also that "the *postindian* must waver over the aesthetic ruins of *indian* simulations."[9]

For Vizenor, the *postindian* is both the mark of the distorted representations of the Native American and the response to the simulated quality of the Indian; the *postindian* performs a bifurcated oral history that wavers between fictional creation and lived experience.[10] Part shape-shifter, part "warrior of survivance," the *postindian* demonstrates for Vizenor a way out of a thought pattern that continually repositions the Native American in the mythological *pose* of the Indian. However, Vizenor's understanding of all Indianness as essentially "postindianness" also cuts to the heart of the strange paradox of Indian as both utter fiction and fleshly reality, as both pure representation and daringly real. Ultimately this inaugurates an additional space between the Indian as simulation and an Indianness that allows for notions of Indianness unfettered from the poor simulations of the Indian to exist and come to the forefront. I humbly suggest that this new specter of Indianness, especially as employed by Monkman, is intimately intertwined with futurity. When I was first thinking of how to approach the specific topic of Native American performance art for this essay, I immediately thought of the essential and ethical task of positioning native art in relation to performance art and perhaps *as* performance art precisely because of this overwhelming padlock that disallows most conceptions of all things native to exist in the present, much less the future. Postmodern art and performance practices have a slightly Svengali-like relationship to time and temporality, and as such an invitation to think of Native American art/performance in relation to modes of performance art such as Happenings and Fluxus[11] is a rather efficacious event given this explicit

emphasis on making art and performance that tampers with temporality to the point where linear time is rendered strange.

The *postindian* must waver over the aesthetic ruins of *indian* simulations. This is why *futurity* is of more interest here than the *future* (as in the time that will come after the present), since futurity, as I have come to understand it with the help of texts such as *The Utopian Function of Art and Literature* by Ernst Bloch, is about a willful longing for a future moment that can emerge as radically new and different from the present and past. For Bloch, hope is modeled as the *utopian function* wherein the stuff of hope is first glimpsed in the realm of the imagination and then extended "in an anticipating way, [into] the existing material [of] the future possibilities of being different and better."[12] To reimagine nativeness, it would then seem, is not merely to decide on a different kind of nativeness; rather, the task is to imagine the positionality and constitutive horizons of nativeness differently. This potentially reimagined nativeness is always necessarily peering out over the horizon, for the utopian function of imagination leads "existing facts toward their future potentiality of their otherness, of their better condition in an anticipatory way."[13] This is inevitably a forward movement, perhaps an oscillation or wavering between; anticipated—yet not quite here. This anticipatory quality of the imagination is, for Bloch, ineluctable to the extent that our very condition is one of a *noch nicht,* "not yet," which signals ours as a continual movement of becoming. Monkman's work is ultimately pedagogical in showing us how tinkering with the landscape of the past, of painting Cher into that past—a fitting placement as she is decidedly ageless and timeless—highlights that among the many things that colonial contact altered was an indigenous understanding of gender and sexuality replete with two-spirits and shape-shifters. Painting such ideas back into the landscape is part of a longing, an anticipation, not for the past but for a radically new future in which Indianness can be seen and felt as a more expansive category of art and racial demarcation.

110

The first time I encountered Monkman's work was at the 2005 "Performing Heritage" *encuentro* in Brazil. Kent was a participant in the "Defining Indigeneity" roundtable event. It was a lightning rod moment in the ten-day marathon of performances, workshops, panels, and conversations about indigenous performance. I say lightning rod precisely because as the encuentro unfolded, "heritage" became sort of an inadvertent euphemism for "tradition," and the phrase "performing heritage" unwittingly became something akin to what Rey Chow calls "coercive mimeticism," in which the ethnic subject is compelled to enact the predetermined image of the ethnic in order to authenticate the expectation of that particular ethnicity.[14] To a certain extent, this is about playing Indian; and playing it correctly. Seen through the lens of Deloria's *Indians in Unexpected Places,* this illuminates the simple fact that the fictive expectation of nativeness is often at odds with the fleshly materiality of native persons and communities. That said, the strategic word choice "indigeneity" indeed carries with it the potential to highlight the precise modes in which one becomes indigenous, generally through the mechanisms of colonialization; but in this instance the word choice waned under the pressure and desire of encuentro participants to consume indigenous performance that would fulfill the desire for an authentic heritage. Perhaps it was for this very reason that when Monkman began his talk about the quandary of "defining indigeneity" with a slide of his work *Artist and Model,* it felt like a lightning bolt struck the room.

Artist and Model is beautifully painted and ornate; it depicts an idyllic landscape that gestures to artists such as Cornelius Krieghoff and Paul Kane, both active in colonial Canada in the 1800s (FIG. 35). It is so idyllic and so impeccably painted that at first the audience did not register the utter strangeness of the content: an Indian attired in a headdress, pumps, and loincloth standing at an easel painting a white male figure who is tied to a tree, pants at his ankles, held still for the artist with a bevy of arrows. As a slight preamble, Monkman told the audience that he "has

a thing" for Cher, which results in his painting her into his landscapes. While this "thing" for Cher is a complex identification, it was clear from the first slide that Monkman's visceral definition of indigeneity was concerned with how the Native American has served as, and still often becomes, the unwitting subject of ethnographic and colonial visual art. Without a doubt, part of the critical work that *Artist and Model* does is to invert the relationship between the colonial eye and the spectatorial Indian subject/object. I speak of the work that *Artist and Model* does for two reasons: one, to make clear that what is under consideration here is how Monkman's art works within the social world, and two, to make abundantly clear that my voice as a performance scholar is not the same as Monkman's, nor am I offering an explanation of this work. This latter caveat is important to the extent that there can be no simple and final account for the life of any art piece. So, to allow for the continued mystery of Monkman's work, I must assert that the following discussion is not a journalistic rendering of the thrust of Monkman's paintings and performance but rather an active engagement and investment in how this work is approached critically. All of which is to say, in this writing I am positioning myself as a critical fan of Monkman's work.[15]

From this position of investment versus appropriation and explanation, I say that Monkman's visual mapping of the moment of colonial contact is deserving of repeated attention. Clearly, *Artist and Model* reorients this moment; however, this reorientation happens at least in part because of the visual debt that Monkman owes to nineteenth-century North American painting in particular. Monkman's overtly palpable and biting critique of these landscapes in regard to the ethnographic gaze upon the Native American is not done from outside the artistic practice of landscape portraiture but, conversely, from *within* this tradition.[16] This type of critique serves to sustain the form in an effort to reengage with the content; it offers a modality of criticism that advocates for working *with* a questionable object versus a flat disavowal of that object. Part of

the history that *Artist and Model* references is how landscape masters such as Kane were commissioned to produce a specific content within their work. The particular history of how such grand-scale images were produced for the wealthy patrons who commissioned them is far from depoliticized. Although we might understand all artistic production and practice as intimately intertwined with the coercion implicit in patronage, the works in question underscore the willful imagination and expectation of nativeness.

If part of the effects, if not process, of colonization involves the appropriation of the colonized subject by means of the ethnographic gaze, then a counterpart is the tampering with the cosmological beliefs of an indigenous population. What galvanized my attention during Monkman's talk at "Performing Heritage" was the difficulty of attending to the nexus of nativeness and queerness. In Monkman's aesthetic narrative, this uneasy confluence of queer and native had its roots in the impact colonization and Christianity had on indigenous understandings of gender and sexuality. Prior to contact, native cosmological beliefs such as two-spiritism and shape-shifter mythology indicated a radical delineation from what we might recognize as a certain homophobic ideology that was later trafficked in under Euro-Christian imperialism.[17]

Landscapes such as Monkman's *Heaven and Earth* gesture to the impact of colonization on indigenous notions of sexuality with a playful and willful reimagining of who got to top whom in the moment of colonization and conquest (FIG. 36). If read merely as a wishful alternative ending to the historical narrative of the colonization of North American native peoples, the image offered in *Heaven and Earth* falls flat in that we *do* know—at the end of the day—the cowboys won. Surely, the many political/spiritual/geographic instances of native resistance are important, but considering that no amount of wishful intervention can reverse the fact of colonization, *Heaven and Earth* functions as an insistence of an *indigeneity* that is always already ripe with a queer potentiality.

114

While Monkman spoke that day of his desire to locate his work in the mixed-blood space between his Irish and Cree ancestral cultures, his desire to articulate this bifurcated racial marking in relation to queerness resists the overworked cultural studies über term "intersectional." To say "queerness in relation to nativeness" is rather strategic. One, this steers clear of implying that these two minoritarian markings simply "intersect" with no interaction; and two, it insists upon a notion of queer that is akin and indebted to texts such as Roderick Ferguson's *Aberrations in Black: Toward a Queer of Color Critique,*[18] which locates queerness within and through histories of racial formation, colonialism, and transnationalism. This necessarily locates queerness as not only invested in dissident and non-normative sexualities but also as invested in other anti-normative formations inclusive of, but not entirely restricted to, race. Monkman's *Heaven and Earth* demands such a theoretical tool. The unsettling nature of the painting is only made more insistently explicit by the display of gay male homosexual sex on the frontier floor. The buffalo, wounded but still formidable, looks on to the practice stage set forth by Euro-Christian colonization, in which queerness, non-normative spiritualities, and racial formation are dismantled in an effort to dovetail with Euro-Christian imperialism.

Like *Artist and Model* and *Heaven and Earth,* Monkman's *Portrait of the Artist as Hunter* is not what it seems to be at first glance—an iteration of the warrior Indian motif on horseback (FIG. 37). Upon closer inspection, you will notice that the Indian warrior is replete with a red sash and high heels. In one way this is merely a substitution of one accessory for another. The object is only funny to the extent that it does not fit the scene and is, thus, out of place. But there is a lack of visceral parody within this landscape. In Monkman's aesthetic twist, the red sash gently unfolding and billowing alongside the majestic white stallion is as it should be. This inclusion, or aesthetic accumulation, of the red sash ushers in another modality of Indian regalia instead of highlighting

FIG. 37 *PORTRAIT OF THE ARTIST AS HUNTER*, 2002, KENT MONKMAN

ACRYLIC ON CANVAS, 24 × 36 IN.

the potential oddity of a feminine male Indian warrior. Representations and tales of two-spirited native sexuality are not absent within some of our native cosmologies and traditions, but they are sparse on the level of Native American or First Nations landscape portraiture. While this alone would warrant critical attention, it is the particular fashioning of Monkman's alter ego, Miss Chief Share Eagle Testickle, on Cher that commands attention.

We can conjecture a few things about the *Miss Chief* series: that Monkman is invested in playing with the image of Indianness proffered

up in relation to Cher's "Half Breed" persona, and that he is trying to disrupt this image. And, that he really likes to depict Cher as already *playing Indian,* which highlights how simulation is used in this work not as a mimicry of any indigenous realness but as a gesture to the always already simulated fact of Indianness. Perhaps with this painting in mind we can really hear Vizenor's contention that the *indian* is always a simulation. However, within this graphic representation there is not a pure absence of the native in that Monkman's delicious rendering of Miss Chief Share Eagle Testickle as a simulated scene of Indianness enforces his willful insistence on the legacy of two-spiritism within native cosmologies.

But what might it mean to achieve this insistence by way of Cher's "Half Breed" persona? For those of you untouched by the 1970s, '80s, and '90s and unfamiliar with present-day pop diva Cher and her #1 hit song "Half Breed," let me digress for just a second. Cher, as half of the folk duo Sonny and Cher, was not new to the top of the U.S. Billboard Hot 100 charts; "I Got You Babe," performed with Sonny Bono, spent three weeks as #1 on the U.S. Billboard Hot 100 in August 1965. In September 1973, "Half Breed" topped the Billboard charts for two weeks, becoming Cher's first solo #1 hit. The song was the first international release from Cher's album *Half Breed* and was a #1 hit in Canada, a Top 10 hit in Sweden, and a Top 20 hit in Norway. In 1973, Cher performed "Half Breed" on *The Sonny and Cher Comedy Hour*. Dressed in the Indian regalia costume that would mark her place as muse to fashion designer Bob Mackie, Cher sang the epic tale of racial ambiguity from the back of a shiny Pinto pony. The song narrates the difficult lot for the half-white, half-Cherokee, half-breed subject. Hailed as an "Indian squaw" by white folk and "white by law" by the Cherokee tribe, the tragic heroine finds herself at the hopeless site of a racial indeterminacy so confounding to those around her that her only option is to traipse from "man to man." The recorded performance of the song on *The Sonny and Cher Comedy Hour* became one of Cher's first videos and is included in *The*

Very Best of Cher: The Video Hits Collection (2004). The visceral doppel-ganger of Monkman genteelly placed on a disinterested pony looking just out of the shot is perfect even on a proportional level: the same amount of background frames the side-standing equine and Cher, replete with a floor-grazing white and rhinestone feather headdress and other Native American props including wood carvings (totem poles), fire, and, of course, the astoundingly over-the-top regalia designed by Mackie. During the "Defining Indigeneity" roundtable Kent mentioned that he knew he was not supposed to identify with Cher because she was not a real Indian. Without wanting to wade into the common controversy of determining what qualifies any person as native, it bears noting that the unflappable rumor that Cher is half-Cherokee directly correlates to the release of her *Half Breed* album in 1973. Performing the song "Half Breed" secured Cher an identity as verifiably Native American despite the also publicly disseminated information that she is half-Armenian and half-Irish. Again, this is not a debate on whether Cher is in fact of Indian

FIG. 38/39 **THE TAXONOMY OF THE EUROPEAN MALE**

PERFORMED JUNE 25, 2005, AS PART OF THE EXHIBITION *THE AMERICAN WEST*, CURATED BY JIMMIE DURHAM AND RICHARD WILLIAM HILL AT COMPTON VERNEY, WARWICKSHIRE, ENGLAND

descent, especially given the emphasis on Indianness as a simulation; the issue here is how by the act of singing the lyrics of "Half Breed," Cher *becomes* Indian. In what utterly performative (i.e., to engender, transform, bring into being) ways do these lyrics produce the materiality of Cher's social/racial/ethnic heritage? It is strange precisely because Cher has also sung about being a thief and a gypsy—in "Gypsies, Tramps and Thieves"—and a murderess—in "Dark Lady"—but these lyrics do not refer back to Cher in quite the same way.

There is a sense that Cher is compelled into Indianness by the song "Half Breed." It is perhaps frustrating to some that Cher rarely denies or affirms the often explicit question of her plausible Indian identity. This refusal is—to my mind—a reminder that which persons get deemed Indian by way of blood quantum politics, and how Indian is scripted and understood within the social context, is at the very best arbitrary. Taking this arbitrariness as the standard rather than the exception, we can busy ourselves with the more pressing question of how Monkman's work is compelled, if not *propelled,* by the specter of Cher. Of course, we cannot answer *why* Monkman is attracted to Cher in the creation of his alter ego Miss Chief Share Eagle Testickle. Rather, the task is to consider, perhaps, how Monkman's work functions inside native communities and what his work essentially does within art markets.

Photographs of Monkman's performance *The Taxonomy of the European Male* illustrate precisely how the compositional elements of his work are contoured by Cher's "Half Breed" video (FIG. 38 and 39). On some level this seems almost frivolous, but in light of Monkman's work it is crucial precisely because it offers us an opportunity to witness the relationship between playing Indian and Native American performance; the relationship between the performance of Indianness, which most generally is the hyperbolic performance of the savage or noble Indian á la cowboys and Indians, and the autonomous

FIG. 40 *THE TAXONOMY OF THE EUROPEAN MALE*

PERFORMED JUNE 25, 2005, AS PART OF THE EXHIBITION *THE AMERICAN WEST,* CURATED BY JIMMIE DURHAM
AND RICHARD WILLIAM HILL AT COMPTON VERNEY, WARWICKSHIRE, ENGLAND

performance art made by Native Americans. Surely these reference vastly different modalities of performance that evoke different kinds of aesthetics and performance practices, but the dividing line is not as easily located as it might seem.

It is a difficult divide in part because of the strange wedge that Chow's notion of coercive mimeticism drives between these two modes of performance. How might we understand the scripted performance of Indianness coercively compelled from the Native American artist and person? In other words, what about the Native American who in various situations finds herself or himself "playing Indian"? Keeping true to Chow's understanding of coercive mimeticism as a situation in which the ethnic subject is compelled to enact the predetermined image of the ethnic in order to authenticate the expectation of that particular ethnicity, the concept would also apply to the quotidian and everyday performance demanded of Native American persons to *act Indian,* to live up to the expectation of Indianness (FIG. 40). But Monkman's tricky, evident love of Cher-turned-performance-of-Cher provides another way to think about this relationship. If an identification of the simulacrum of Indianness is the improper identification, as opposed to the perhaps proper identification of traditional Cree or otherwise indigenous art, is Cher a deviant, impure (i.e., non-traditional) influence? Perhaps; maybe there is an inherent danger in mistaking oneself for a popularly consumed simulation of such a self. Or, more likely, does this very question obscure the fact that one, who better than members of indigenous communities to know how their representation has failed them; and two, that turning away from these ill-fitting and often painful simulations does nothing to rid the native community—artist or otherwise—of them. Might we, then, read Monkman's work as a biting repetition, indeed a deviant translation, of those often compassionless images of squaws, Land O'Lakes butter tub maidens, wooden cigar-store Indians, and the never-ending panoply of "Tontos" offered up to us in the genre of the

western? Such a perspective would indicate how this Native American art practice defiantly translates and accumulates such images into a necessary reminder that they present the indigenous community with an uncanny image of itself.

However, viewing the still from *The Taxonomy of the European Male* next to the still of Cher's performance-cum-makeshift-music-video of "Half Breed" from the Sonny and Cher show, it seems clear that Monkman's work explicates the ebb and flow, the relationship, the choreography if you will between the performative nature of Indianness and the work of Native American artists. I like to think of this choreographic event as something of an aesthetic waver. In a last turn to Vizenor's edict that "the *postindian* must waver over the aesthetic ruins of *indian* simulations," we can now understand how there is perhaps an impulse or need for Native American performance to embody an allegorical *waver* between the occidental creation or simulatedness of the Indian and the fleshly lived experience of the Native American. To waver is to oscillate, to shuttle between, to reverberate and often in the process to allow for something radically new and even perhaps unexpected. The waver between Monkman's alter ego Miss Chief Share Eagle Testickle and Cher's "Half Breed" persona is ripe with the potential to make a space between the Indian-as-simulation and lived experience. This space is held open by the waver, the reverberation between the two images; and it might be in this vibration that a new Indianness emerges at the nexus of indigeneity and queerness. Or, perhaps an Indianness that is always already queer; or more so a queer identity that weaves within and through histories of racial formation, colonialism, and nationalism, and as such is positioned as a queerness that is not only invested in dissident and non-normative sexualities but anti-normative formations in general. And, from where I was sitting that day at "Performing Heritage," I indeed heard Kent Monkman articulate his definition of indigeneity as decidedly queer.

NOTES

1. Kay WalkingStick, "Native American Art in the Postmodern Era," *Art Journal* 51, no. 3 (1992): 15–17.

2. Gerald Vizenor, *Fugitive Poses: Native American Indian Scenes of Absence and Presence* (Lincoln: University of Nebraska Press, 2000), 15.

3. *Remix: New Modernities in a Post-Indian World,* co-curated by Joe Baker and Gerald McMaster, Heard Museum, Phoenix, Arizona, and National Museum of the American Indian, New York City, 2007–8.

4. The long history of the phrase "the vanishing race" begins, of course, with Edward Curtis's 1904 photograph, titled *The Vanishing Race,* of a series of Navajo men riding away from the camera on horseback toward the shadowy edge of the frame. Although this piece became the paradigmatic Curtis image, it also became a visual metaphor for the bulk of Curtis's career, which spanned three decades: that Native Americans and Native American culture were vanishing. For some background on the vexed history of Curtis's work, see William R. Handley and Nathaniel Lewis, eds., *True West: Authenticity and the American West* (Lincoln: University of Nebraska Press, 2004); Elizabeth S. Bird, ed., *Dressing in Feathers: The Construction of the Indian in American Popular Culture.* (Boulder, CO: Westview Press, 1996); Angela Aleiss, *Making the White Man's Indian: Native Americans and Hollywood Movies* (Westport, CT: Praeger, 2005); Mick Gidley, ed., *Edward S. Curtis and the North American Indian Project in the Field* (Lincoln: University of Nebraska Press, 2003); and Scott B. Vickers, *Native American Identities: From Stereotype to Archetype in Art and Literature* (Albuquerque: University of New Mexico Press, 1998).

5. Such performance practices would necessarily include the artists Pamyua (Alaska), Ranferi Aguilar (Guatemala), the Mapuche Drama Project, and MapUrbe Communication Workgroup (Argentina).

6. Hortense Spillers, "Notes on an Alternative Model— Neither/Nor," in *Black, White and in Color: Essays on American*

Literature and Culture (Chicago: University of Chicago Press, 2003), 315.

7. For more information on the history of blood quantum regulations and United States–American Indian tribal relations, the following texts can be helpful: Eva Marie Garroutte, *Real Indians: Identity and the Survival of Native America* (Berkeley: University of California Press, 2003); M. Annette Jaimes, ed., *The State of Native America: Genocide, Colonization, and Resistance* (Cambridge, MA: South End Press, 1992); Hardy Myers and Clay Smith, *American Indian Law Deskbook* (Boulder: University Press of Colorado, 2004); Francis Paul Prucha, *The Great Father: The United States Government and the American Indians* (Lincoln: University of Nebraska Press, 1984); Circe Sturm, *Blood Politics: Race, Culture, and Identity in the Cherokee Nation of Oklahoma* (Berkeley: University of California Press, 2002).

8. Philip Deloria, *Indians in Unexpected Places* (Lawrence: University of Kansas Press, 2004), 14.

9. Vizenor, *Fugitive Poses,* 15.

10. Vizenor is referring to Jean Baudrillard's conceptualization of the simulation and the simulacra in which the signifier masks the basic absence of the signified. The simulation as such lacks both a referent as well as authentic experience. In Vizenor's use of Baudrillard's simulation, the emphasis is placed on consumption and reproduction of the image and its problematic relationship to the real-life referent.

11. For more information on the history of Fluxus art and the Happenings, please see Sally Banes, *Greenwich Village 1963: Avant-garde Performance and the Effervescent Body* (Durham, NC: Duke University Press, 1993); Ken Friedman, ed., *The Fluxus Reader* (New York: Academy Editions, 1998); Hannah Higgins, *Fluxus Experience* (Berkeley: University of California Press, 2002); and Mariellen R. Sandford, ed., *Happenings and Other Acts* (New York: Routledge, 1995).

12. Ernst Bloch, *Principle of Hope,* vol. 1 (Cambridge, MA: MIT Press, 1986), 144.

13. Ernst Bloch, *The Utopian Function of Art and Literature: Selected Essays* (Cambridge, MA: MIT Press, 1989), 105.

14. Rey Chow, *The Protestant Ethnic and the Spirit of Capitalism* (New York: Columbia University Press, 2002).

15. Writing from the position of "critical fandom" refers to a highly self-reflexive methodology that allows the scholar to think alongside the persons/objects or analysis rather than flatly analyze such. Key readings include Myriam Diocaretz and Stefan Herbrechter, eds., *The Matrix in Theory* (Amsterdam: Rodopi, 2006); Matt Hills, *Fan Cultures* (London: Routledge, 2002); David Muggleton and Rupert Weinzierl, eds., *The Post-subcultures Reader* (New York: Berg, 2003); and Virginia Nightingale and Karen Ross, eds., *Critical Readings: Media and Audiences* (Maidenhead, England: Open University Press, 2003).

16. Peter Edlund's work is also of interest here as he also works with Hudson School landscapes in a similar vein to Monkman: http://www.realartways.org/archive/summer2000/index.html. Last accessed 6/23/2009.

17. For nuanced discussions on the impact European colonization had on indigenous forms of spirituality and sexuality, please see Colin G. Calloway, *One Vast Winter Count: The Native American West before Lewis and Clark* (Lincoln: University of Nebraska Press, 2003); John Tully Carmody and Denise Lardner Carmody, *Native American Religions: An Introduction* (New York: Paulist Press, 1993); Sabine Lang, *Men as Women, Women as Men: Changing Gender in Native American Cultures* (Austin: University of Texas Press, 1998); Joel W. Martin, *The Land Looks After Us: A History of Native American Religion* (New York: Oxford University Press, 2000); Elvira Pulitano, *Toward a Native American Critical Theory* (Lincoln: University of Nebraska Press, 2003); and Siobhan B. Somerville, *Queering the Color Line: Race and the Invention of Homosexuality in American Culture* (Durham, NC: Duke University Press, 2000).

18. Roderick Ferguson, *Aberrations in Black: Toward a Queer of Color Critique* (Minneapolis: University of Minnesota Press, 2003).

APPENDIX A:
SUGGESTED READINGS ON
KENT MONKMAN'S WORK

Buttery, Helen. "From a Native Perspective." *The National Post,* September 9, 2000.

Cooper, Melissa. "Award Winning Cree Painter's Work Transfixes." *The Drum,* December 2000.

———. "Monkman's Blood River Premieres." *The Drum,* March 2001.

Davies, Jon. "Manned Claims." *Xtra Magazine,* October 13, 2005.

Falvey, Emily. "Hot Mush and the Cold North." Ottawa Art Gallery (catalog essay), June 2005.

Fung, Richard. "The Big Picture Feature." *Lola Magazine,* issue 13, Fall/September 2002.

Furnish, David. "Kent Monkman." *Interview,* March 2006.

Grimley, Terry. "A Pioneering Exhibition." *The Birmingham Post,* August 18, 2005.

Hill, Richard William. "The American West." Compton Verney (catalog essay), June 2005.

———. "Dressing Up and Messing up White." *FUSE Magazine* 23, no. 4 (2001).

Kennedy, Maev. "How the West Was Lost: The Other Side of the Cowboy Myth." *The Guardian,* June 24, 2005.

Lack, Jessica. "The Nationality Issue." *i-D Magazine,* vol. II/IX, October 2005.

Liss, David. "Miss Chief's Return." *Canadian Art*, Fall 2005.

McIntosh, David. "Kent Monkman's Postindian Diva Warrior." *FUSE Magazine* 29, no.3 (July 2006).

Mitchell, Catherine. "Grasping the Narrative Tool." *Winnipeg Free Press*, March 1, 2001.

Sinclair, Clive. "Cross-dressed to Kill." *Times Literary Supplement,* August 19 & 26, 2005.

Waboose, Jan Bordeau. "Setting the Stage: Kent Monkman." *Aboriginal Voices,* September/October 1995.

Wright-Mcleod, Brian. "A Nation Is Dancing." *Aboriginal Voices* 5, no. 4 (1995).

FIG. 41 *PORTAGING RIDEAU, PADDLING THE OTTAWA TO KANATA*, 2005, GREG A. HILL

PERFORMANCE IN OTTAWA, ON

CHAPTER 7

PERFORMING AS SOMEONE ELSE AND THE PIED PIPER EFFECT

Greg A. Hill

The following is an edited and supplemented version of an oral presentation at the Denver Art Museum's "Advancing the Dialogue" symposium on Native performance art held April 4–5, 2008. The talk was accompanied by videos, so I have had to put into words much of what the audience at the time was able to observe directly for themselves. I have attempted to preserve the spoken voice in this text version of that live presentation.

First, I want to say thanks to Polly Nordstrand and the Denver Art Museum for the invitation to come down and talk about my artwork. Because I work as a curator—I am presently the Audain Curator of Indigenous Art at the National Gallery of Canada—I don't really talk about my own artwork that much anymore. My curatorial job has eclipsed my artwork, and that I think is expected, but it does make it important to me to have an opportunity like this. Today, I am pleased to be able to talk with you about some of my performances. My most recent performance work was back in 2005, so you can understand what I am talking about when it comes to my new curatorial priorities. For this talk on performance art and the camera, I will look at several performances as examples of different ways the presence, deployment, documenting/

archiving function, and autonomy of the camera affected the performance and/or the audience.

The title I chose for this talk is "Performing as Someone Else and the Pied Piper Effect," and I will explain what I mean by it in a moment. But first a few words on performance art and some of the other presentations we have had here today. One thing that has come up in discussions of performing is the topic of the various personae that artists take on. James Luna referred to it as "being in the zone"—not unlike, I think, what an actor experiences while in character, or, perhaps, what a visual artist experiences in a creative moment. The "space" of the performance is a creative zone that has fluid boundaries. Those boundaries are multilayered and overlapping, as they are defined by spatial, temporal, cultural, and personal norms. When I talk about "performing as someone else," I am talking about a release from the rules—through the character or anonymity of the assumed persona—or even freedom from personal inhibitions that constrain us in ways we may have learned to accommodate and also those we might not expect or that take us by surprise. Being able to act or inhabit an alternate or "optional extra" persona enables me to explore the personality—real or imagined—of the character necessary to the performance. I will return to this idea as I explain how I use various personae in my performances.

To get back to the title for my talk, what I refer to as the "Pied Piper Effect"[1] is something that has occurred during several of my performances, where the spectacle of doing something odd—something outside of the expected norm, in public space—leads to people following you, curious to see what is going on. It is interesting to think about this desire: is it curiosity or spectacle that draws people, or something else? It could simply be the presence of camera crews and their insinuation that this event is significant in some way, that it is newsworthy, which in this age of mundane reality television is not really saying much. The effect, however, is that an audience materializes where there was none.

The cameras are at the performance to document the event for a post-performance audience. Ironically, the presence of those documentary devices is what, I would argue, draws in an audience for the live event.

As we consider the "camera" in performance art, I suggest that we think about whether one is performing in front of that camera or whether the camera is there merely as a documentary tool. A particular performance, or a performer's entire practice, may in large part be about the performer's relationship with the audience. How is this relationship impacted by the presence of cameras; and further, should or *can* the performer interact with one or the other or both? I think of the camera as another kind of spectator. This "spectator" represents all future viewers of the recorded live event. However, the camera is really a record of one viewer's experience that is then shared with others. If there were everal cameras recording an event, and these individual records were edited into a single communal record, the resulting document would still be a mediated experience of the live performance. It would reflect the personal and professional choices of the camera operator(s) as well as those decisions made during the editing process. I think that both this mediated audience and the live viewers have to be taken into consideration. How can the unpredictability of a public audience impact the performance? How does the presence of a camera affect the live audience, their relationship to the performer, and the performer's interaction with them? What happens when the cameras documenting a performance become part of the performance? I think all of these different scenarios have been at play in performances I've done, at times all at once. And, finally, one other aspect of the camera and performance that we can discuss is the transformation of photo and video documentation into art objects.

PORTAGING RIDEAU, PADDLING THE OTTAWA TO KANATA

In my 2005 performance *Portaging Rideau, Paddling the Ottawa to Kanata*, the presence of the camera, in this case multiple video crews and still photographers, was a major factor in the performance itself. The crews were there for different purposes: one I hired for documentation, another came from local television news, and another was there to shoot a television production on contemporary art, eventually to be broadcast on the Aboriginal Peoples Television Network (APTN).

The objects in this performance come out of a series of works that are about making—or trying to make—"traditional" objects as an urban Kanyen'kehaka (Mohawk) person. It's about using materials that are readily at hand in a city, as opposed to what might be available if I were in a rural area and had access to birch bark, for example. For this performance I used several items such as a headdress, shoulder bag, and, especially, a canoe I had made out of cereal-box cardboard. The performance that day was about me meeting the challenge, the constant question that arises whenever the canoe is exhibited, about whether or not it actually floats. I had, at every occasion, strongly asserted its floatability and finally I wanted to put that question to rest. The canoe, I think, is the best example of the continuum of authenticity that objects made by Aboriginal artists must contend with. It is an object immediately recognized and generally known to be of Aboriginal origin, but the expectation is that it would be made out of "traditional" materials, such as birch bark. A canoe made out of a material such as cereal-box cardboard is a challenge to what is expected. The material is unproven and quickly dismissed as improbable, and it is reasonable to ask the question: is a canoe that does not float still a canoe?

For the performance, I started by portaging my canoe out of the Ottawa Art Gallery, where it was on exhibit, through the Rideau Mall and down to the Ottawa River, where I then got into it and paddled

around (FIG. 41). Stepping back for a second, there are a couple of double entendres in the title of the performance I would like to explain; *Rideau* refers to the Rideau River, the Rideau Center mall that I portaged through, and the Rideau Canal that I portaged over. The *Ottawa* is the Ottawa River, from which the city of Ottawa takes its name, and *Kanata* was the final destination for the performance, which is an island that is known now as Victoria Island. The island is a sacred site, a gathering site for the Algonquin people and an important part of an active land claim. The Algonquins are trying to reclaim some of that space. This includes the site where the parliament buildings are. All of it is unceded Algonquin territory. There is a whole political history that is very important to this area and is not so well-known. The rivers, the island, the parliament buildings, even the mall, are significant features in the Ottawa cultural landscape. My hope was to create some awareness about the contested nature of these spaces by drawing attention to them through this action. I was honored by the presence of Algonquin elder William Commanda, a canoe builder himself and a very active proponent in the struggle to have some of these lands returned to the Algonquin; in particular, the island, where his dream is to build a center for Indigenous cultures.[2]

In the space and time of portaging my cereal-box canoe on a Sunday afternoon from the Ottawa Art Gallery to the Ottawa River, in total a walk of about 15 minutes, we picked up about 100 people who decided they were coming along for the ride. I would like to think that the "followers" had pieced together the subtle clues from my clothing, what I was carrying, where I had come from, and where I was going that this spectacle was the byproduct of a critical investigation into the nature of recuperated personal and constructed national identities and contested histories. But I suspect it was the roving gang of photographers and videographers that signaled to people that something "important" was going on. So the camera, in this case multiple video crews and still photographers, was a major factor in the performance itself. In the

different videos, the groups keep crossing into each other's views. At times, you can see a fuzzy boom microphone in several of the shots.

Quite aside from the politics, I think what the followers were able to quickly evaluate was that here was a person carrying a canoe, water was not too distant, and the cameras indicated this might be something worth watching. Really, I think everybody was just waiting for me to sink. Fortunately, it didn't happen. I was able to paddle the canoe, that is until the cardboard started to get soggy. My foot made a hole and I ended up having to carry it to a point where I could cross the river over to "Victory" Island where I planted a Kanata flag, ending the performance.

That action ended the event but the performance lives on in various forms—the documentation is edited into a video I use as an element for the display of the canoe, and there is the television show, which is regularly rebroadcast.

KANATA FLAG DAY

I have mentioned that in addition to my documentation of *Portaging Rideau, Paddling the Ottawa to Kanata*, footage was produced for the television program *The Sharing Circle* and broadcast on APTN. The program actually consisted of three interrelated stories that were based on my work and the work of Nadia Myre and Jeff Thomas, all of which were skillfully interwoven by directors Kristin Tresoor and Vanessa Loewen into a view of contemporary Aboriginal art practice that they called *Not Just Beads and Moccasins*. What Kristin and Vanessa did for *The Sharing Circle* I am citing as an example of high production values and how the documentation of performances is altered through the skilled use of the camera and application of a journalistic narrative.

Not Just Beads and Moccasins also looked at other performances I did around the idea of Kanata Day and the creation of a new flag for Kanata. There were several performances based on this concept that took place at different times in different cities. In one performance,

Kanata Flag Day (Parliament Hill, Ottawa, 2001),[3] I posed as a news reporter and showed visitors to Parliament Hill what I told them was a new flag design for "Canada" to go along with a name change for the country from "Canada" to "Kanata" (FIG. 42). They were handed an "official" media release announcing the changes and asked if they would agree to provide their opinions on camera on the new flag and name change for the country. Further context to the setup was that this was all done in the days leading up to Canada's Flag Day on February 15, which was posited as the time for the changeover to the new flag.

Responses to the changes varied but were generally supportive of the explanation that these alterations were being undertaken to better recognize the significant contributions and sacrifices Aboriginal peoples in Canada had made to the country. The Kanata flag has the same colors and basic layout as the official Canadian flag, but in the place of the maple leaf, there are three feathers. The idea for the three feathers comes from the traditional Kanyen'kehaka headdress, a *kahstowa*, which has three feathers standing up as a Kanyen'kehaka signifier. My use and explanation of the three feathers on the flag was that it represented all

FIG. 43 *ANYTHING TO DECLARE?*, 2005, GREG A. HILL

PERFORMANCE FOR SOLO EXHIBITION, *TEKWANÒNHWERATON TSI KEN'EN KANATA NITISEWENONH/WELCOME TO KANATA/BIENVENUE À KANATA*, AT GALLERY 1C03, UNIVERSITY OF WINNIPEG, WINNIPEG, MB

Aboriginal peoples in what is now (formerly) known as Canada—the groups the government knows as the First Nations, Inuit, and Métis—it became a pan-Aboriginal symbol although there was this more personal signification as well.

My ongoing project to refashion all of the prominent symbols of the country known as Canada was launched during the year 2000 millennium commemorations. I sent a letter to the prime minister that read, in part: "I feel it is important to point out there is a typo in the way Canada is spelled. Canada should read 'Kanata,' this is the original word that has come to symbolize the country. 'Kanata' is the Rotinonhsyonni (Iroquoian) word for town or village. Included is a corrected version and logo that can be used in place of the other one—free of charge, of course. Please do not be too embarrassed by this mistake. I am sure no one (in your government) really noticed." I exhibited this letter, the government's bureaucratic and dismissive response, the *Kanata Flag Day* video, and a full range of Kanata products a number of times over the following years.

I employed the video as part of the work as a means of dissemination of the ideas and a subversion of the medium itself by posing as the media to promote Kanata.

ANYTHING TO DECLARE?

I want to talk now about this performance, which first took place in Ottawa in 2001 for my *Welcome to Kanata* exhibition in the lobby of the Department of Indian and Northern Affairs Canada (INAC) and was later remounted for the opening of *Welcome to Kanata* in 2005 at Gallery 1C03 at the University of Winnipeg (FIG. 43). *Anything to Declare?* operated from the premise that the two gallery spaces constituted "micro nations." These two galleries were unique in a physical sense. They are each spaces within a space—temporary walls in INAC's lobby are used as a place for contemporary Aboriginal art, and Gallery 1C03 has a similar

island of a room in the main entrance thoroughfare of the university. Both of these unique spaces facilitated the conceptual framing that these were independent nations.

I conceived of these galleries as tiny countries, with all the heraldry and insignia befitting a modern nation-state—flags, passports, and a controlled border, complete with customs officer. The exteriors of the galleries were adorned with Kanata signage and flags, and the interiors provided an "entrance" to Kanata with a red carpet, flags, and welcome mats. Inside, you could purchase t-shirts, flags, and other souvenir items; but, to get inside you had to pass through Kanata Customs.

For these performances I took on the guise of a Kanata customs officer, which happens to be what my father did for the Canadian government for thirty-one years. He worked as a customs officer on the Peace Bridge, which joins Fort Erie, Ontario, to Buffalo, New York. As a Canada customs officer, an aspect of his job was the enforcement of Canadian sovereignty, which I thought was really ironic for a Mohawk to be doing and was something I wanted to work with in my art.

For my *Anything to Declare?* performances I wore my father's (Kanata modified) customs uniform and I stood at the entrance to the gallery space behind a lectern. Visitors would have to line up and go through Kanata Customs to get into the gallery. All were given Kanata passports, which doubled as exhibition catalogs, and after answering a few required questions I would stamp their passports allowing them entry into Kanata. I greeted each visitor in Kanyen'keha (Mohawk), English, and French: "Tekwanònhweraton tsi ken'en Kanata nitisewenonh, Welcome to Kanata, Bienvenue à Kanata . . . Please step forward and have your passports ready." Then I'd say things like, "Will you be buying or receiving anything during your time in Kanata?" and "You may proceed . . . Enjoy your stay."

KANATA DAY MARCH

On July 1, 2005 in Winnipeg, with the assistance of the good people at Urban Shaman gallery, we held a community march to the downtown "forks" area from the gallery (FIG. 44). By some coincidence, the official Canada Day ceremonies happened to be taking place there at the same time. Preparations for our walk involved getting all the volunteer marchers outfitted with Kanata T-shirts, flags, stickers, and temporary tattoos and practicing a few cheers to liven up the long hike.

We had a video crew and gallery staff documenting the march. This created both a sense of spectacle and a set of protective eyes and ears for all the marchers. I was a little concerned that we would run into some overzealous Canada Day celebrants who might take issue with our non-Canadian celebration. Apart from smiles, stares, honks, and shouts as we made our journey, there was no tension until we reached the epicenter of the celebrations at the forks—the junction of the Red and Assiniboine rivers in what is now downtown Winnipeg. Historically this place was a camp and trading site for Aboriginal peoples; now it is a park and tourism center. When we arrived in this place we were confronted and questioned about what we were up to. We continued through the Canada Day revelers to our destination at the center of the park where an Aboriginal-run celebration was taking place. There, we were able to set up flags and hand out Kanata items to an engaged audience and were even invited to join in the dances and activities underway.

The Kanata Day performance was framed as a march countering the official Canada Day events. The mood was celebratory and subversive. At a quick glance we were a group of Canada Day marchers, but a more concentrated gaze revealed that we were a group of mostly Aboriginal people carrying flags with feathers where a maple leaf would normally be. It was a great deal of fun, and some of the participants got very into the performance. It was amazing to see their willingness to take on this kind of subversion of the official day of Canada. There were times I had

FIG. 44 *KANATA DAY MARCH,* 2005, GREG A. HILL

PERFORMANCE IN WINNIPEG, MB

denied the political nature of the work . . . but of course it is political when you take a national symbol like a flag and alter it. It's not a violent act—like burning or defacing a flag—but it can still get heated. I consider that one role of art is to raise awareness; when we question the notion of Canada as a country, and put an Aboriginal face on it, we are saying that we know very well that Canada is a different kind of space for Aboriginal people. Consider the high suicide rates, poor housing conditions, reserve conditions, unemployment, as well as conditions for Aboriginal people living in urban centers. It becomes important to make a simple but profound statement: "We are still here. This is what we are." For the *Kanata Day March* we were a large unified group, and we also benefitted from the protection offered by the camera's steady gaze.

The television production spanned several performances to provide a larger context for the Kanata work. There was footage of me being interviewed specifically for the show and the *Kanata Day March* but also footage from my *Kanata Flag Day* video, showing me going out and asking people about the name change and the new flag. They also added historical footage from 1964–65 when the modern Canadian flag was being decided on and debated. The television production created another level of documentation of my performance practice. As a form of documentation, the television medium adds a level of authority to the work. But at the same time, we all know such programs are heavily edited, that they create an altered version of what was a live event. And on yet another level, sometimes the camera, or the record that it makes, is part of the performance itself, as in the *Portaging* performance. The Kanata Project, with the *Kanata Flag Day* video, was designed to create the fictive notion that changing the flag had already happened. Distributing that video, and the video as an object in the Kanata exhibitions, was part of the overall project. The camera plays many different roles in this project.

142

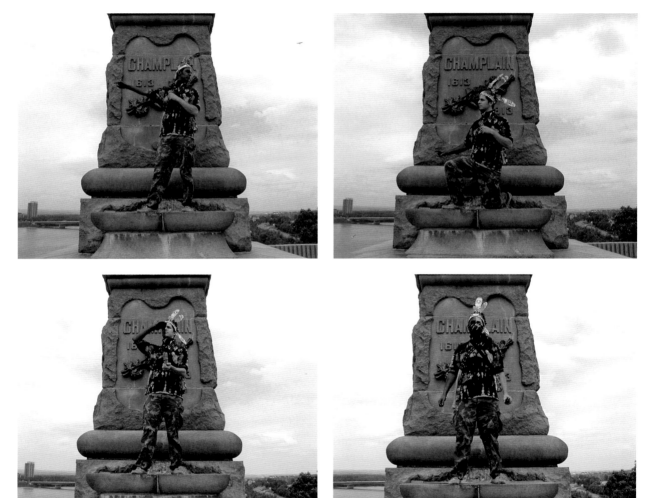

JOE SCOUTING FOR CIGAR STORE LASAGNA

This performance was done in Ottawa in 2001 and was documented by a live webcast as well as still photos and video (FIG. 45). The title—*Joe Scouting for Cigar Store Lasagna*—may sound odd, so I'll explain. "Joe" is a persona that I take on: Joe, Joseph Brant, or Thayendanegea (1742–1807)—a well-known Mohawk leader during the time of the American Revolution and a contested figure from a Haudenosaunee (Iroquois) perspective and therefore a rich persona to explore. I do a pose as Thayendanegea (Joseph Brant), which comes from a memorial portrait of him painted by William Berczy in 1807. The "scouting" refers to the statue of the Anishinabe scout that used to be in the same place where I stand during the performance but has been removed for political reasons. I assume the pose that the scout was in and an imagined character for this bronze statue; "cigar store" is yet another pose, that of the familiar eye-shaded gaze of the wooden Indian holding a handful of cigars; and finally, "lasagna" refers to the warrior pose of Ronald "Lasagna" Cross, one of the principal characters in the Oka land dispute in 1990, who was infamously photographed in his camouflage fatigues in a standoff with a member of the Canadian military, which became the stock media image for the conflict. For the performance, I repeat these four "poses" in a path that traces the movement of the Anishinabe statue from its original location to its current one in a park across the street.

The purpose of this performance was to rejoin the scout to its original location at the base of the Champlain monument. The Assembly of First Nations staged a political protest at the monument, citing the subservient position and demeaning nature of the sculpture as an historical example of attitudes affecting contemporary issues. The statue was eventually removed from this site, secretly, and with no form of redress, and reappeared, months later, across the street in a garden of "indigenous plants." The performance sought to address this erasure of historical and contemporary context and bring these issues back into

the public eye.[4] I repeated the poses between the two locations, making tobacco offerings along the way in what I saw as a ritualistic rejoining of the scout to the monument. Apart from the politics of the scout's removal, there were many other aspects to that performance—media was one of them. It was heavily documented. There were five cameras. There was a live web broadcast and a webstream of that original broadcast available on the Internet for the next year. The local media showed up, and there were clips broadcast on a local cable television show. In all its various forms, this is another instance where the documentation of the event became a kind of event unto itself.

REAL LIVE BRONZE INDIAN

There is one last performance I want to talk about, and it also draws on the Anishinabe scout and his removal from the Champlain monument. We were able to use Ottawa's former land registry building, an unused heritage building across from SAW Gallery in Ottawa, for this performance in 2001 (FIG. 46). From architectural stone that was stored in the building, we created a monument base to suggest the base of the Champlain monument and the site of the scout statue. I re-created the rest of the monument through slides and a video projection that cycled through the four poses I described earlier. For the exhibition opening, I got up on the platform and did this performance where I inhabited the persona of the Anishinabe scout. I was thinking about what it might be like to be a bronze statue—frozen in place and having people come and sit on me and pose for their souvenir tourist photos. I thought of myself cemented in that position but having a voice.

For the performance, I started by doing nothing but holding the pose of the scout until everyone became completely bored and left the room. After they were all gone, I started calling out for people to come and get their pictures taken with me. I had a camera there and proceeded to goad people into coming up on the platform and taking pictures

with me. It was interesting what people started to do. One guy stuck his gum on my leg; people were hugging and kissing me and doing all kinds of strange things. I really felt like the scout, or what I imagined the scout would feel like. The viewers became part of the performance; in particular, they were performing as tourists for the camera as they might do with an actual statue. However, in this instance the agency resided in the statue. The statue's desire for tourist photos—photos of tourists, that is—provided the ironic twist.

The idea was to turn the tables on the viewers. To use the passive form of a bronze statue and animate it, creating this loud and obnoxious character starving for the attentions of the tourist viewers; not for them to take their own photos, but rather, the images of the tourists and their poses become the souvenirs of the statue. The photos themselves are both documentation and art objects.

From these descriptions of some of my performances you can see that there are multiple roles that the camera plays. Performance artists have different views on the evidentiary role of the camera. I consider documentation important. It is a necessary means of creating a record of the event as part of an ongoing art practice, but I believe it is also important to create these records and have them available so that they can contribute to a body of work that will (hopefully) become part of an Indigenous art history. As an artist, I feel a sense of responsibility to place ideas, objects, and actions in the public domain; not to be presumptuous, but I hope that these things will become part of a vibrant and critical discourse on and within Indigenous art.

In these times, cameras are ubiquitous witnesses to nearly every aspect of our lives. We document our personal and familial lives. We are captured on security cameras and monitored as we walk or drive on public thoroughfares, and we engage in watching others as well. That the camera and performance art have a long and inextricable history is perhaps a moot point; more vital is the intersection between the camera

and Aboriginal performance art, where this relatively new, lens-based medium is enmeshed with a performance practice that has ancestral roots in ceremony and ritual. I am inspired and informed by those performers and artists who pass on their knowledge and creativity through action, repetition, and documentation.

Nyawen kowa. All my Relations.

NOTES

1. There are many versions of the legend of the Pied Piper of Hamelin, dating back to the 13th century; essentially the piper leads the town's children away as revenge for not being paid for ridding the village of its rat infestation. I could not help but think of this as I led the followers down to the Ottawa River during one performance. Fortunately no one ended up in the water.

2. An online document with Commanda's plan can be found at http://www.destinybydesign.ca/CANposters/2005GWCreport Pgs6to10.pdf. Last accessed April 15, 2009.

3. This can be viewed online at http://homepage.mac.com/ gahill/artwork/iMovieTheater32.html. Last accessed April 15, 2009.

4. See also the photographic work of Jeff Thomas, whose images and thoughts on the scout were also a counterpoint to the removal and erasure.

FIG. 47 *THEY CALL ME WANJIKU*, 2008, MŪMBI KAIGWA

PERFORMANCE AT THE MARTIN E. SEGAL THEATRE CENTER, CUNY, NEW YORK, NY

OUT OF THE ARCHIVE
PERFORMING MINORITY EMBODIMENT
Tavia Nyong'o

The archive is first the law of what can be said, the system that governs the appearance of statements as unique events. But the archive is also that which determines that all these things said do not accumulate endlessly in an amorphous mass, nor are they inscribed in an unbroken linearity, nor do they disappear at the mercy of chance external accidents; but they are grouped together in distinct figures, composed together in accordance with multiple relations, maintained or blurred in accordance with specific regularities; that which determines that they do not withdraw at the same pace in time, but shine, as it were, like stars, some that seem close to us shining brightly from afar off, while others that are in fact close to us are already growing pale.

—MICHEL FOUCAULT, *THE ARCHAEOLOGY OF KNOWLEDGE*[1]

If performance art emerged as a strategy for evading the perceived permanence, connoisseurship, and valorization of prior genres like painting and sculpture, and if it has therefore held the ambiguous allure of being peculiarly "unmarked" among the arts, then its adoption by native and

minority artists as a strategy carries with it a number of ironies. What difference is there between the unmarked status toward which live art aspires, according to Peggy Phelan's influential claim that performance "becomes itself through disappearance," and the fate of invisibility to which racial and indigenous populations are so often consigned?[2] What "other histories" of "coerced mimesis" might be omitted from Eurocentric narratives of performance art that consider it to have arisen only in the wake of the 1960s, and only in response to specific pressures related to the development and criticism of modernism and postmodernism?[3] And what of the enduring importance of cultural memory to the dispossessed and devastated, for whom the melancholic attachment of live performance to an evanescent present may only preempt opportunities for a more thoroughgoing mourning of the past or a more pertinent engagement with the politics of the present?[4]

These questions reverberate in much contemporary minoritarian performance art. Mũmbi Kaigwa's *They Call Me Wanjiku* provides one example. I saw it performed in New York City in the summer of 2008, as part of *Eti! East Africa Speaks*, the first festival of East African performance art in the United States.[5] Kaigwa's solo performance (with musical accompaniment) touched upon the displacement of original language and culture by the Christianizing and colonizing process in Africa and centered on a feminist meditation upon the loss and recovery of matrilineage as a dynamic cultural principle (FIG. 47). According to Ngũgĩ wa Thiong'o, Kenya's most famous novelist and playwright, cultural displacement has created the need for "decolonizing the mind."[6] Extending Ngũgĩ's terms, Kaigwa's theatrical objective might be thought of as a decolonizing of the body. Indeed, in *They Call Me Wanjiku*, acts of naming, memory, and narrative form the locus at which the registers of "mind" and "body" meet and overlap. It is perhaps because of this intertwining that, unlike the project of decolonizing minds (at the center of which is the reclamation of native languages for literatures),

decolonizing the body lacks a defined process or direction. Decolonizing the mind held the promise of a suitably recognizable objective: mental independence to accompany political independence. The very title of Kaigwa's performance, by contrast, announces its ambiguities. Who called her Wanjiku? Was this the wrong name to call her? What should we call her? And if we have to ask, does that suggest that perhaps we are the "they" in her title? Performing identity in the flesh, it would seem, produces a different order of temporality than does the establishment of national or ethnic literatures. For this reason, it renders the "archive" as a collective repository of knowledge less an automatic solution than a vexed question, one this essay seeks to explore. How is the indigenous body to recover from acts of erasure, misunderstanding, and territorial dispersion if the body itself is not ever, except in fantasy, capable of the full and stable self-representation that the recording and preserving function of the archive expects of its privileged objects? To investigate these questions, we might follow Foucault in going beyond the conventional understandings of archive as repository, or system of record collection, to grasp it, as he suggests in the epigraph, as a principle of *enunciability*, shaping what can be known, shown, thought, or said. It is in relationship to this Foucauldian definition of the archive, which I discuss further at this essay's conclusion, that my questions are posed.

These questions, I believe, should resonate within the field of Native American performance art and scholarship. They make the point that a consideration of the present era of globalization offers opportunities "to rethink race, sexuality, and gender as concatenations, unstable assemblages of revolving and devolving energies," as Jasbir Puar has argued, "rather than intersectional coordinates."[7] There is a growing interest in investigating the categories of "woman," "native," and "other" as precisely such unstable assemblages, and not essences, that operate unexpectedly to link and relay otherwise dispersed experiences.[8] Recent years, for instance, have witnessed a happy efflorescence of scholarship

in Afro-native studies, as two excellent anthologies attest to.[9] The subtitle of one—*Crossing Waters, Crossing Worlds: The African Diaspora in Indian Country*—suggests a complementarity between the fields of black and native studies found in the interlocking metaphors of *diaspora*—the casting of seed—and *country*—homeland as territory. Theoretical concatenation is hinted at in the question the editors, Tiya Miles and Sharon P. Holland, pose in their introduction:

> *What happens when key issues in African diasporic experience, such as migration, freedom, citizenship, belonging, peoplehood, and cultural retention and creation, and key issues in Native American experience, such as tribalism, protection of homelands, self-determination, political sovereignty and cultural-spiritual preservation and renewal, converge?[10]*

The range and quality of the work Miles and Holland gather in response to this question (indeed, the sheer range and intensity of affect that the very proposal evokes among those placed personally or professionally along the Afro-native continuum) underscores the productiveness of their approach of interlocking histories.

Yet at the same time as the essays gathered in *Crossing Waters, Crossing Worlds* underscore the timeliness of such a convergence, they also point to additional configurations of blackness and indigeneity that remain to be mapped. In particular, they point to postcolonial space and time, where the instructive metaphor is less *convergence* than it is *juxtaposition*. Juxtaposition between black and native cultural politics works not only because of intricately and inextricably linked histories, but also because such comparisons appear at a time when artists are being hurried toward a global, homogenized art world even as the work of decolonization and native sovereignty is unfinished. Furthermore, such juxtapositions, as I will argue in my conclusion, dovetail with a method of rereading the archive along lines proposed by the scholar Walter Benjamin,

as giving access not to a continuous, stable past, but a "time filled by the presence of the now."[11] In the working through of comparative minoritarian embodiment in performance that follows, I focus less upon the recovered link between black and red peoples than I do on a complexly spatial and temporal predicament into which successive waves of conquest, empire, colonization, and now globalization have thrust racialized and nativized communities. I do so in hopes of being of some use to the artists who struggle to embody and rearticulate those experiences against the amnesiac imperatives of much of contemporary society.

ENUNCIATING THE TRIBAL SELF

They Call Me Wanjiku was performed in New York several months after a traumatic wave of violence struck Kenya. A dispute in that nation over the results of a presidential election provided the spark that lit the tinder of simmering grievances, ones often linked in the media to land disputes going back to Kenyan independence in the mid-1960s, but which took a fearsome shape when a politics of ethnic chauvinism stoked the nihilistic fury of thousands of youth who felt cheated of education, employment, and any decent future. The toxic brew that nearly toppled Kenya held precisely those ingredients Miles and Holland align on the "native" side of the column, "tribalism, protection of homelands, self-determination, political sovereignty and cultural-spiritual preservation and renewal."[12] In the violence's wake, a renewed determination to articulate strengthened national institutions and identities took hold. Exploring these issues fully (which space constrains me from doing here) certainly underscores how discourses of race, ethnicity, and aboriginal land claims, rather than producing a consistent political vantage point (even an intersectional or coalitional one), are rather "grouped together in distinct figures, composed together in accordance with multiple relations," as my epigraph from Foucault suggests.[13] This postmodern context for the ethnic and gendered name is ineluctably an interethnic and international

one, underscoring the unfinished nature of efforts to restore cultural autonomy through the proper name or tongue.

The poignancy of *They Call Me Wanjiku*, as a small drama of interpellation, climaxes with the complaint that "they say my name . . . but not the way that I say it."[14] The postcolonial predicament of being alienated, distanced, askew even from one's given name in acts of misprision extends but also remaps the decolonizing imperative of Ngũgĩ's generation. Kaigwa's attention to gender, both in her narration of the matrilineal clan system of her Gikuyu people as well as in the multiple female voices that emerge dialogically during her piece, further highlights the performativity of the speech-act of naming, which can serve to veil as well as to highlight genealogy. Put another way, once gender is factored into the equation, the reclamation of names, cultures, and identities can no longer be a straightforward, singular event—much less a dramatic rupture with the institutional structures of empire. Between the kinship matrix and its postmodern rearticulation there emerges a kind of indwelling, immanent, and performed critique of the symbolic order that calls out or names and fixes us in our place. While such a reading is certainly not required to appreciate Kaigwa's performance, a Lacanian grasp of the symbolic as anchoring the paternal law in language illuminates our understanding of it. By shifting the emphasis to the act of pronunciation, that is, to the "material-phonic substance" of the name "that is transferable but not interpretable," as Fred Moten puts it, Kaigwa re-echoes her interpellation within the symbolic law with an augmentation of the proper name that renders it improper to the task of delimiting identity.[15]

Juxtaposing Kaigwa's performance of the ambiguities of naming with James Luna's *The Artifact Piece* (1987, 1990) further illuminates the drama of interpellation. Luna lay on display in the San Diego Museum of Man exhibit on a bed of sand, draped for modesty but otherwise exposed to the curious viewer (FIG. 17 and 18). The gap between what visitors

initially took Luna to be and the breathing, listening "specimen" they were confronted with was held open by the playful display cards they were invited to peer in to read; cards that offered not the expected ethnohistorical information about the native "type" on view but details regarding a specific body the audience was invited to imagine was the one lying before them. Mixed or missed messages thus emerge of critical concern to both Luna and Kaigwa; *The Artifact Piece* also suggests: "You see my body . . . but not the way that *I* see it." Such performances effectively show how the privilege of ignorance preserves relations of dominance at the same time as it offers new, if playfully evasive, information.

Juxtapositions need not be dependent upon similarities. I have noticed, for instance, that tribal affiliations are routinely appended to proper names at conferences and gatherings and in articles and books that focus on Native American issues. The perhaps self-evident purpose of such identification contrasts noticeably with standard practice among similar events and publications by Africans, who are rarely identified more specifically than by nationality. Of course, a *tribe* is also a *nation* from one perspective. But what is of interest to me here is that Africans have tribal identifiers as well as national ones, only we generally do not use them in intercultural or international settings. They are taken to be obvious to those who are clued in and of little importance to those who are not. Despite the nonchalance with which ethnicity is implicitly rather than explicitly enunciated, it can be intensely meaningful, in ways that not even nationality always is.[16] A migrant might remain tightly interwoven within a transnational kin network that waxes even as his or her connection to (even citizenship in) the postcolonial nation-state wanes. Conversely, in recent African history, we have learned to our grief that ethnicity can kill, leading at least one postcolonial nation, Rwanda, to legislate against the use of ethnic identifiers.

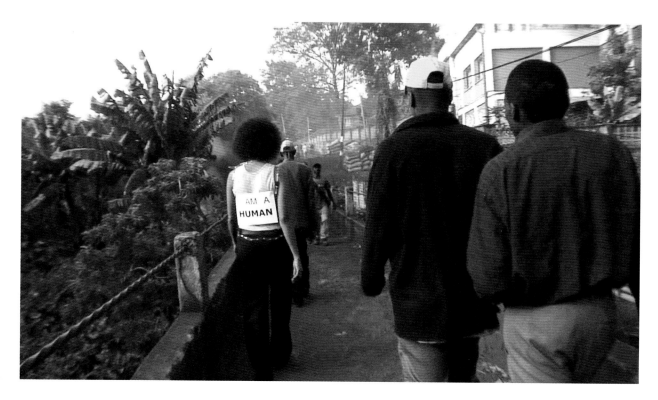

FIG. 48 **HUMAN WALK**, 2008, I ngridM wangiR obertH utter

VIDEO STILL

A 2008 installment of the ongoing *Human Walk* consists of Kenyan-German artist Ingrid Mwangi walking through sections of Nairobi, a city recently wracked by ethnopolitical violence, wearing signs on her back and front reading "I am a Kenyan" and "I am a Human" (FIG. 48). In this performance, murder and destruction are mourned through the purposeful elision of ethnicity, a tactic also adopted by the website http://www.ihavenotribe.com/. When considering these examples against the labored efforts to reclaim and reconstruct tribal identities in native North America, it becomes clear that the "work" that ethnicity does in the contemporary moment cannot be reduced to a single generalization. A principle of what Foucault calls enunciability makes "tribe" speakable, even imperatively so, in some contexts, and quite unspeakable in others. I think this difference is not fully explained by pointing to apparent and

real differences between the histories and political situations of Native Americans and Africans or diasporic peoples of African descent. Rather, I believe the task of Afro-native studies remains in the archive of colonizing, nativizing, and racializing projects, projects whose logic amounts to neither a single seamless system nor "an amorphous mass" but a complex historical and geographic grid, within which we still think and act.[17] The abandonment of an imaginary and dispassionate standpoint outside the social totality, from which we can pronounce definitely on the direction of historical flow, follows as a preliminary axiom of inter-ethnic solidarity. While it may be ethically and politically essential to make recourse to the nation-state and international civil society as the guarantors of human rights, the efficacy of individual or even group declarations of particularity do not seem to be a foregone conclusion. A fuller investigation is called for before we can pronounce such global solidarities an unqualified success.

Here it is useful to turn to Rey Chow's provocative and illuminating study of the ideology of ethnicity within contemporary globalized society. Her concept of "coercive mimeticism" is helpful for thinking through the conditions placed upon native and black performance art. It also offers a small history of modernity, within which overlapping categories like native, primitive, and indigene figure as emblems of a project to interpellate and dominate the non-white world. While the concept of mimeticism has fallen into deserved disrepute in anthropologically oriented approaches to performance, it remains, as Chow shows, an indispensable theoretical tool for fleshing out the complexities faced by performers engaged with embodying themselves, their names, and their histories in museums, galleries, and beyond.

PERFORMANCE ART AND COERCIVE MIMETICISM

Mimesis has long been a critical category of analysis for performance studies, as Michael Taussig has shown in his study of how mimesis

mediated the opposed categories of "self" and "other" in colonial modernity.[18] Chow has shrewdly observed that mimesis, although sometimes associated with an outmoded approach to culture, remains "perhaps, the central problematic in cross-ethnic representation in the postcolonial world."[19] This is so because although the realist categories of representation upon which mimeticism ostensibly relies have indeed been subject to a thoroughgoing critique, the fraught terrain between "representation" and "imitation" that it so explicitly navigates remains at issue, often as *the* issue, for a range of aesthetic and political strategies of minority and indigenous artists. Performance art's promise to deliver the presence of the body without the burdens of representation that bedevil prior art forms like painting, photography, and sculpture, as I mentioned earlier, has been less a point of departure for indigenous and racialized performance artists than a bone of contention. Insofar as the body upon which art is performed, for these artists in particular, is interpellated in the social and symbolic order as the site of difference, otherness, and exotic expectation, it necessarily carries with it a history and, in a manner of speaking, an archive. So if the field of performance studies has wanted to abandon the admittedly crude concept of *imitation* for the subtler range of meaning conveyed by *repetition, restoration, reenactment,* even *repertoire,* that repressed term, "imitation," tends to return as a symptom in any discourse that adjudicates the ethical or political efficacy of ethnoracial and/or indigenous performance art. Work that fails to meet those ethical or political standards can be cast off as "imitative" of a (white) avant-garde or critical practice.

Chow's productive notion of "coercive mimeticism" helps account for why this should be so. Chow divides mimesis into three levels that also form, very loosely speaking, an historical sequence. She sees the first level of mimesis as the simplest, but also the level at which the colonizing and racializing project is exposed in its starkest form. At this level, the white male is the only true and original subject, and the Indian, native, or

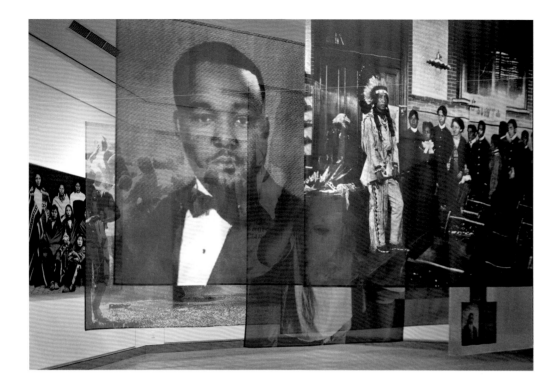

FIG. 49 **THE HAMPTON PROJECT**, 2000, CARRIE MAE WEEMS
INSTALLATION VIEW OF EXHIBIT AT WILLIAMS COLLEGE MUSEUM OF ART, WILLIAMSTOWN, MA

colonial other is always construed as attempting but failing to reproduce this image. Richard Henry Pratt's project to "kill the Indian and save the man" at his Carlisle Indian Industrial School in Pennsylvania exemplifies this stage of mimesis in its nonchalantly genocidal impulse, insofar as the model of "man" was indisputably Western, white, and male. Carrie Mae Weems's 2000 installation, *The Hampton Project*, transforms period photographs taken by Frances Benjamin Johnston at another school with a civilizing mission, first for African Americans and then Native Americans, into a disquieting palimpsest of past and present (FIG. 49).[20] A performed version of such a palimpsest can be found in Rebecca Romero & Co.'s *Big Girl, Little Girl* (performed at the American Indian Community House in New York City on June 7, 1996), which satirizes this imitative mimesis through a hyperbolic exercise in feminine etiquette that repeatedly burlesques the white ideal as it reaches toward it. In the video of the

performance, the audience giggles as the performers exteriorize their submission to ladylike flourishes that periodically devolve into showbiz theatricality. The quaintness of the gentility displayed, itself an historical ideal without any contemporary referent, bespeaks a redoubled loss that the performance duo somehow suggests: the very success of assimilation to Eurocentric norms, as documented in the photographs Weems restages, becomes an invisible archive of a loss now outside memory but not, sadly, therefore beyond injury. Reenactment, an increasingly critical question for performance art, is clearly at issue here.

The second level of mimeticism retains this dualistic structure of colonizer and colonized, but, as Chow puts it, shifts the focus to what the subject undergoes through her or his attempts at mimetic whiteness. "Failure" is redefined as a productive ambiguity and uncertainty that ultimately reflects back on the supposedly stable subject of whiteness, distorted in the fractured mirror of the "not quite white." *Big Girl, Little Girl* works toward such an unsettling of mimesis as it progresses and can be usefully juxtaposed to Lorraine O'Grady's *Mlle Bourgeoise Noire*, a 1980 performance intervention in which the artist wore a dress stitched out of thrift-store gloves, a pageant sash, and a tiara and stormed art openings to interrupt what she perceived to be the unthinking reproduction of exclusionary standards and institutions of artmaking and exhibition with disturbing acts of self-flagellation. At one opening she attended, Mlle Noire performed this poem:

> *WAIT*
>
> *wait in your alternate/alternate spaces*
> *spitted on fish hooks of hope*
> *be polite wait to be discovered*
> *be proud be independent*
> *tongues cauterized at*

openings no one attends
stay in your place
after all, art is
only for art's sake
THAT'S ENOUGH don't you know
sleeping beauty needs
more than a kiss to awake
now is the time for an INVASION![21]

Reflecting upon her interventions in 2007, O'Grady explained that Mlle Bourgeoise Noire and her masochistic disruptions sought to strike at mimesis through inhabiting its incoherences:

> *It's true that black bourgeois women worldwide were sexually repressed in this era. What else could they be when they were defined by their surrounding cultures as the universal prostitute? They were desperate for respect. In 1980, black avant-garde art, another middle-class construction, was equally repressed. THAT's why Mlle Bourgeoise Noire covered herself in white gloves, a symbol of internal repression. THAT's why she took up the whip-that-made-plantations-move, the sign of external oppression, and beat herself with it. Drop that lady-like mask! Forget that self-controlled abstract art! Stop trying to be acceptable so you'll get an invitation to the party![22]*

Performing the psychoanalytic truism that what is repressed will return as a symptom, Mlle Bourgeoise Noire exhibits a hysteric, excessive, masochistic presence within the museum space. Mimesis here transforms from within into an urgent critique of its psychic costs, even as Mlle Noire's performance redistributes the accumulated weight of that repression by impressing upon her audience an awkward acknowledgment of complicity. The "now" of the poem became the "time" of an

invasion that infused Mlle Bourgeoise Noire's masochistic acts with a political demand. I am particularly interested in how the poem produces a site of enunciation that was neither O'Grady nor Mlle Noire, and thus, an exemplary instance of the testifying subject I will discuss in my conclusion, one situated "in the disjunction between a possibility and an impossibility of speech."[23]

If critical mimeticism of this sort interrupts the static nature of whiteness as an unchallenged model with discomfiting stagings of ambivalence, however, Chow argues for a third development in our present era of globalization characterized by an increasingly officious multiculturalism. This is the level at which the ethnoracialized or indigenous subject is officially relieved of the burden of imitating whiteness, only to have the emphasis shift to the demand that she or he represent otherness. Be Asian! Be native! Be black! These are the commands that bind the subject coercively, not to what she is *not*, as was the case with colonial mimesis, but to what she *is*. The work of native performance artists like James Luna and Rebecca Belmore (*Artifact 671B*, 1988) was particularly trailblazing in modeling an aesthetic response to the work of coercive mimeticism, insofar as indigenous subjects are among the most regular of subjects to receive the demand to represent or display their authentic and timeless cultures.

The irony of coercive mimeticism is that to perform who you are, to represent the traditions, cultures, and language of one's people, is to be everything that the avant-garde, cosmopolitan, iconoclastic performance artist is not. It bifurcates the public's understanding of native and minority performance into either authentic cultural performances or derivative imitations of a Eurocentric avant-garde. That a direct mimetic imperative to represent otherness endures despite repeated critiques—such repetition, Slavoj Žižek notes, being the very logic of disavowal—can be seen in recent ethnographic zoos in Belgium and Germany exhibiting African tribes.[24] It can also be seen in news reports from the summer of

2008 erroneously reporting upon a previously "uncontacted" isolated tribe in the Amazon (FIG. 50). In this latter case, the point is less the unquestioned continued existence of cultural alterity (otherness) than the rarely acknowledged operation of coercive mimesis in the production and dissemination of that difference. Almost two decades after Guillermo Gómez-Peña and Coco Fusco satirized the Western obsession with "discovering" new indigenous tribes, the same official discourse of proscribing "contact" with the outside world in order to preserve pristine cultures, coupled of course with an intensive media campaign and scientific expedition to effect precisely the opposite, aims to construct the Brazilian rainforest as a kind of geographic diorama, with the "living specimens" on perpetual display. These operations are revealed whenever an ultimate extreme of difference becomes the standard against which minoritarian performances are measured. That all the very latest in globalized technology, publicity, and cultural flow are recruited toward the production of this contemporary spectacle bespeaks the continued power of coercive mimeticism to enchant contemporary capitalist society.

Elaborating Chow's account of coercive mimeticism across the terrain of contemporary performance art, we can see how it situates the indigenous and/or ethnoracialized artist in a double bind. On the one hand, to accede to the command and to be what you already are—the authentic racial self uncolonized by the white world—is in effect to accede to the exoticist gaze of the tourist eager to consume the spectacle of otherness. On the other hand, to reject that role and disclaim any relation between identity and performance would be difficult for an artist in any medium, but particularly one in which the artist's body remains so defiantly, obstinately present. Part of what makes Chow's theoretical schema so helpful for thinking through this perhaps over-familiar dilemma (is one a native artist, or an artist who "happens" to be native?) is the historical dimension she endows it with, thus situating it within an

FIG. 50 MEMBERS OF AN UNCONTACTED AMAZON BASIN TRIBE AND THEIR DWELLINGS ARE SEEN DURING A FLIGHT OVER THE BRAZILIAN STATE OF ACRE ALONG THE BORDER WITH PERU, MAY 2008

PHOTO DISTRIBUTED BY FUNAI

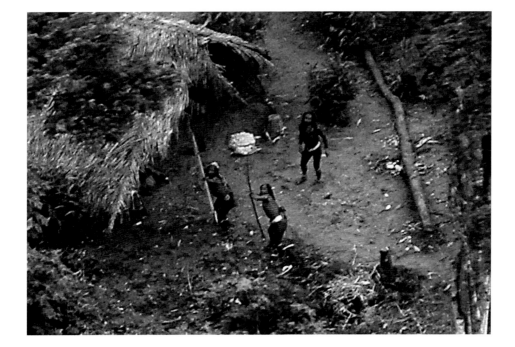

archive of embodied articulations and enunciations of subjectivity. If the tactic of so much minoritarian performance art is to somehow name and make visible this archive and thereby move the body outside or beyond it, then Chow's concept of coercive mimeticism is useful for evaluating the efficacy of such tactics within the constantly shifting strategies of cultural dominance. Conversely, an attention to the aesthetics and phenomenology of performance qualifies some of the more absolute characterizations of coercive mimeticism. Like preceding deployments of mimesis, the compulsion to perform the truth of your ethnic self (in a globalized context within which the notion of discrete and autonomous ethnicities disconnected from intensive flows of capital and culture is increasingly a notional one) is not a self-evident reality but an ideal that, as Judith Butler suggested of gender, must be constantly and anxiously cited in order to maintain itself as a stabilizing fiction.[25]

The point of Chow's intervention is not to deny the possibility of authentic difference within a global economy. To the contrary, it works to show how the possibility of difference transforms into an imperative, and with what consequences. In the fetishistic logic of coercive mimeticism, the ethnic other can never be different enough. Or rather, since in fact even a relatively perfunctory display of otherness is sometimes acceptable to a distracted audience, its fetish is that there always be more difference to be revealed, displayed, and consumed. There is always another African to persuade onto stage, another Amazonian tribe to discover. Rereading the emergence of contemporary performance art by artists of color, we recurrently see the creative engagement and reversal of such a mimetic imperative at work.

Take just two examples. Adrian Piper's *Funk Lessons* (1982–84) confronted the cliché of the effortlessly rhythmic black body by proposing funk dance as a set of instructions that anybody can learn. While a superficial interpretation might construe Piper's performance as emerging from the ethnic capacities of black female embodiment, *Funk Lessons*

in fact proposed the reverse, exposing the arbitrariness of the expecta-
tion of who should be able to teach or learn funk lessons. It sought, in
her words,

> *To restructure people's social identities, by making accessible*
> *to them a common medium of communication—funk music and*
> *dance—that has been inaccessible to white culture and has conse-*
> *quently exacerbated the xenophobic fear, hostility, and incompre-*
> *hension that generally characterizes the reaction of white to black*
> *popular society in this society.*[26]

A more recent two-channel video installation by the performance art
collective My Barbarian, *The Golden Age* (2008), similarly invited its
viewer to participate by executing choreography to a bubbly song
whose lyrics, one discovers as one listens, place the viewer in the role of
a captive African held in the hull of a slave ship on the transatlantic pas-
sage. The jarring simultaneity of horrific content and sunny, even silly
form underscores the coercion of mimesis, which is in this case relayed
from the (virtual) performers to the bodies of the museum visitors, thus
disrupting the spectacle of ethnic difference and, in this case, the bur-
den of the history of slavery, now felt as a shared responsibility of con-
temporary people and not simply the special or particular issue of
post-slave peoples.

Visual art works together with performance to interrupt the logics
of coercive mimeticism, leading many artists to work multidisciplinarily.
Consider the juxtaposition of *Static Drift* (IngridMwangiRobertHutter)
and Erica Lord's *Tanning* series (FIG. 51 and 52). These series use photo-
graphic, digital, physiological, and theatrical techniques of disguise and
display to foil the taxonomic logic that seeks to fix the body as either/
or. The anxiety produced by the imperceptible "racial" sign on the native
body is, I think, not unrelated to the anxiety of naming that Luce Irigaray

suggests characterizes the symbolic and patriarchal law.[27] The specifi-
cally feminist intervention of these works, like that of Kaigwa's, is to
expose the coercive nature of interpellation by imprinting it directly on
the body. Such acts of "impression" present the body as archive. From
the neutral or descriptive to the pejorative, these photographs docu-
ment less the "truth" of the bodies captured by the camera than the "fic-
tions" that are lived as routine and unquestioned realities. In refusing to
provide evidence to placate the voyeuristic hunger of coercive mimeti-
cism, they offer a testimony that offers a way out of its archive.

CONCLUSION: PERFORMANCES AT A STANDSTILL

It should be clear by now that when we discuss the relationship between
performance and the archive, we no longer intend the latter term in its
everyday meaning. My epigraph for this essay is taken from Foucault's
influential methodological statement, *The Archaeology of Knowledge*,
wherein he outlines a way of thinking about the archive that scholars
across a range of disciplines have found extraordinarily generative. The
archive, Foucault argues, is not "the sum of all texts that a culture has
kept," nor is it even "the institutions, which, in a given society, make it
possible to record and preserve" them. The archive is "that which, at the
very root of the statement-event, and in that which embodies it, defines
at the outset *the system of its enunciability*." This should be a useful
approach to the archive for performance studies, given Foucault's direct
evocation of both embodiment and the event. Indeed, Foucault even
places the enactment of this archive "at the level of verbal perfor-
mances," suggesting an even closer affinity between archive and perfor-
mance.[28] But what does he intend in so locating the archive, not in
institutions or documents, but at the root of statements and events and
in the performances that embody them? What he intends, I believe, is
that we abandon the positivist distinction between what we can know

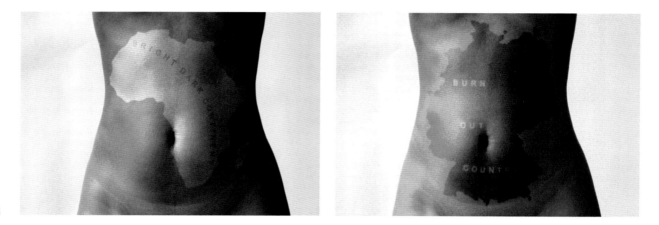

FIG. 51 *STATIC DRIFT*, 2001, IngridMwangiRobertHutter

2 C-PRINTS, EACH 43⅓ × 29½ IN.

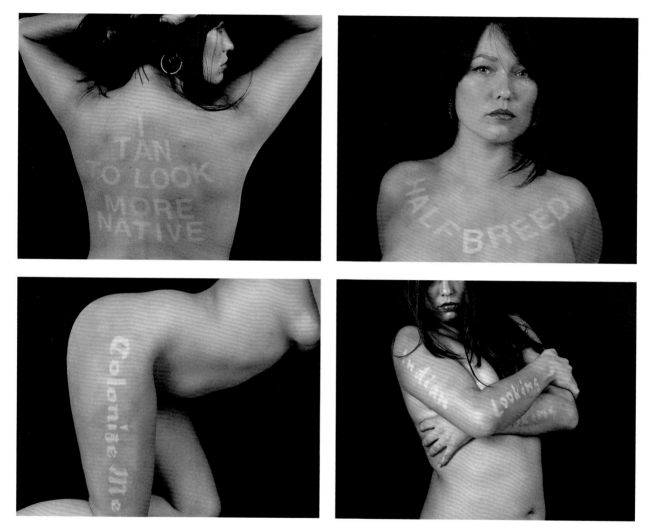

FIG. 52 *TANNING SERIES*, 2005, ERICA LORD

DIGITAL PHOTOGRAPHS, EACH 4 × 5 IN.

and how we come to know it. That is to say, he proposes that we abandon the assumption that discourse is a transparent layer over reality and begin to confront its thickness, its layers and folds, its ruptures, and especially its frayed edges, that is to say, its silences. He invites us to imagine how discourse speaks the body in its division from the flesh.[29]

Foucault's approach to the archive and the past, in other words, is the inverse of the normative imperative of the historical discipline, which is to use the former to reveal the latter ever more fully and legibly to us, to restore the past, in some manner, to itself. Foucault's proposal for an archaeology or genealogy of the body, by contrast, proposes to estrange the past from itself. After Foucault, we can no longer retreat to the quaint vision of the past as an exotic locale to which one might pay a visit. His work insists that encountering the past is not a beneficent cross-cultural exchange, but a disorienting confrontation with the historicity of categories we routinely experience as natural. It is an encounter that furthermore gives knowledge, not of an empirical other, but of a shifting discursive grid. The archive shows us how "the thing that, by means of the fable, is demonstrated as the exotic charm of another system of thought, is the limitations of our own, the stark impossibility of thinking that."[30] As Alex Scott aptly sums it up, the archive "tells us what we can no longer say."[31]

Performance studies has been among the fields that have taken up and creatively used Foucault's reconceptualization of the archive as an active, ordering principle rather than a passive, empirical resource. While it is common in performance circles to claim that the body takes over at the point discourse ends, I would suggest that the silence of discourse is not yet the perpetuation of performance. If performance remains in and through the body, it is a body that, as Foucault argued, is already "totally imprinted by history and the process of history's destruction of the body."[32] This image of history's destruction of the body should not, however, be taken as justifying the disciplinary priority of history

over performance. If we follow Foucault's definition of the archive as a system of enunciability, of an ordering of the relation of the body to speech, then what that image returns us to is the life of the body in performance. If the process of the imprinting and destruction of the body is not taken as the melancholic victory of time over the body's liveliness, but rather as witness to the constellation of forces brought to immense tension in the present, then it might provide a slant view upon a principle by which the archive is undone.

Two intertwined aspects of the Foucauldian archive need to be kept constantly in mind. It is both the law of what can be said and the principle that ensures that the accumulation of what is said can never order itself into an efficient or total system. That is, while it is certainly true that the archive operates as a principle of social authority, its power is not unidirectional, transparent, or stably reproducible over time. It does not even, and this I think is key, stably reproduce the *fiction* of its stability over time. It has so frequently served as a site of tactical minoritarian intervention, for example in the interventions of the curator and artist Fred Wilson, because its official edifice so quickly crumbles when its elisions and contradictions are probed. By insisting upon a distribution of archival power across society, rather than restricting it to the specific institutions and objects that constitute what we ordinarily think of as the archive, Foucault both extends and qualifies its influence. And by making it responsible for what it actively produces, and not simply what it passively retains against the erosions of time, he helps articulate what is at stake for artists and scholars seeking its reformation.

The fragmentary, layered, and discontinuous nature of the archive poses a specific challenge and opportunity to the *perpetuation* of performance. Insofar as the archive, the statements it enables and the grid of knowledge it orders, proves collectively unstable over time, it undermines the oft-valorized evanescence of performance. If everything dissolves, especially immutable concepts, then what does the special

disappearance of performance consist of? The current interest in per-
formance documentation and reenactment presents as many problems
as it solves if it does not confront the survival of positivist conceptions
of the archive seeking to reclaim the terrain it prematurely abandoned to
discourses of the live. The perpetuation of performance, I argue, occurs
neither within nor without the institutions that seek to document and
order it. It occurs wherever we are given, as Hortense Spillers suggests,
"a vestibular subject of culture."[33]

What does it mean to be vestibular to culture, to embody, as it were,
culture's vestibule? Racial, indigenous, and female subjects probably
already know what Spillers means, but it is helpful to turn to Giorgio
Agamben's theory of testimony, which he developed in response to
Foucault's archive, to assist in a fuller explication. If the archive is an
historical repository of systems of enunciability, of what can, at the level
of verbal performances, be uttered or said, then testimony, Agamben
argues, acts as a witness to what *cannot* be said.[34] It is to the unspeak-
able, rather than the speakable, in other words, that testimony must
address itself. In so doing, it produces an outside to the archive, not in
the realm of reality, but in potentiality. Testimony speaks, as the late
African philosopher Emmanuel Eze puts it, to "this past [which] must
address its future."[35] It does so not by supplying its evidences, not by
restoring the past to itself, but by estranging the past from itself in pos-
iting a subject of enunciation suspended between life and the language,
between body and the flesh.

For racialized and/or indigenous artists, the challenge posed by the
archive is at least threefold. First, there is the strongly articulated demand
to counter the dominant narrative through the construction of stable
institutions, artistic genealogies, and collections that define alternative
histories "on our terms." Second, there is the fraught question of how
artists, individually or collectively, will respond to the governing state-
ments of the majoritarian archive, through their own work. And third,

there is the temptation to mark the archive as solely a site of trauma, loss, and melancholia. These three challenges serve to regulate a great deal of artistic production. But when embodied performance can testify to that which is not yet speakable, to a future grounded in an unrealized potential, then performing the archive need not be limited to the past as it was. It points to the performing body as a virtual archive of what might have been.

Kalup Linzy is an artist working in video, installation, and live and recorded performance. His videos borrow imagery, language, and narrative from soap opera, which he splices together using a low-fidelity technique somewhere between a traditional do-it-yourself aesthetic and the now ubiquitous socially networked mode of cultural production. As if to literalize our self-estrangement within language, Linzy dubs in all the voices on his videos, using consumer-grade computer processing to render these voices a parody of the gender clichés his characters embrace: distorted and slightly out of sync. Somehow, this technique does not distance, but further aligns Linzy's work to the sentimentality, abjection, and nostalgia of soap opera and pop music it mimes.

In *Conversations Wit De Churen V: As Da Art World Might Turn*, Linzy portrays Katonya, an upcoming artist struggling to make it in the vicious New York art world while also searching for true love (FIG. 53). In one scene, Katonya is humiliated when all the important figures who have been invited to her pre-opening soiree fail to show up, and her sadistic gallerist forces her to read her prepared address to the empty room anyway. Later, while anxiously waiting in the empty gallery, and in particular anxious over the potential arrival of her lover, Katonya faints to the floor. Like Mlle Bourgeoise Noire, Katonya is a black female subject rendered vestibular to the high-culture world of art, a world in relation to which her failed acts of mimetic identification, at least seemingly, render her both masochistic and abject.

Mlle Bourgeoise Noire was initially funny at the threshold of the museum, and then quickly gets scarier. Katonya, by contrast, remains almost discomfortingly easy to laugh at throughout. Yet what strikes me upon viewing *Conversations Wit De Churen V: As Da Art World Might Turn* is not the amusing way she sends the art world topsy-turvy, but precisely the reverse: how the patent insufficiency of art world institutions to the excesses of need, hunger, and desire she performs exposes those institutions' emptiness. Like Mlle Bourgeoise Noire, Katonya is waiting, but she is not waiting to be admitted into the official institutions that reproduce culture or the systems that guarantee aesthetic enunciability. She is waiting for something more.

While I am not arguing for an historical continuity or chain of artistic influence between O'Grady and Linzy, I am interested in how we might consider Mlle Bourgeoise Noire and Katonya as performances that embody an archive of black masochism that subverts the coercive mimeticism through its testimony. I suggest that we can come to see Katonya as "witnessing" Mlle Bourgeoise Noire, as perpetuating a performance not through reenactment but through virtualization.[36] Katonya waits at openings no one attends, as the mademoiselle warns she would, a sentimental Sleeping Beauty waiting for Prince Charming's kiss, the history of performance art condensed into a constellation of past and present. Here we move from the *perpetuation* of performance to the question of its potentiality. "To think a potentiality in act *as potentiality*," Agamben puts it, "is to inscribe a caesura in possibility . . . and it is to situate a subject in this very caesura."[37] This witness to the unspeakable is the vestibular subject, whose silence performs the caesura.

Erica Lord's *Artifact Piece, Revisited* also performs this function of "witnessing" a prior work. With the insertion of her own body for Luna's, with the accompanying differences in age, nation, and gender and the substitution of explanatory labels particular to her persona, her 2008 restaging of Luna's *The Artifact Piece* neither documented nor preserved

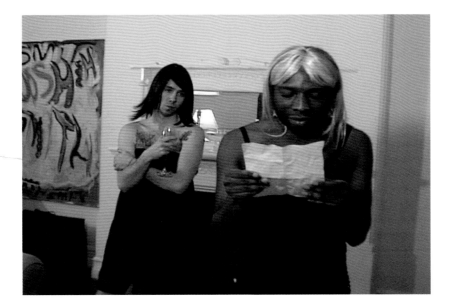

the original so much as it testified to the impossibility of doing either (FIG. 22). In the palimpsest of history that the now in-the-know visitor brings to the piece (unlike the original, the reenactment occurred in a dramatically lit setting in which it was unlikely that even the casual visitor could have stumbled upon the performance supposing it to be an ordinary ethnographic diorama), the particularity of the present is joined to the past in what Walter Benjamin called a dialectical image, bringing history as ordinarily perceived to a standstill.

Mlle Bourgeoise Noire survives in the now-canonized form of her dress, displayed at the entrance of the 2007 exhibition *Wack! Art and the Feminist Revolution*, held at the Museum of Contemporary Art in Los Angeles. But the survival of this performance lies less in institutions than in virtualities, in the thought and affect produced by bringing it into contact with a recent performance like Linzy's. In Walter Benjamin's meditation on the dialectical image of history, he observes that

> *thinking involves not only the movement of thoughts, but their arrest as well. Where thinking suddenly comes to a stop in a constellation saturated with tensions, it gives that constellation a shock, by which thinking is crystallized as a monad.*[38]

To come out of the archive is to emerge into its antechamber, or vestibule, which is a place "saturated with tensions"; that is to say, a place redoubled with the potentiality of the virtual. O'Grady's and Linzy's performances do not form the sequence as much as the constellation, a gendered and sexual "opening" wherein the minoritarian body enacts a masochistic act of waiting that is also a refusal of the constraints of its present.

Performance art cannot of course unilaterally alter the conditions of coercive mimeticism. As a discourse, it conditions what can be said, shown, and performed of native and minoritarian lives, desires, and struggles. The efficacy of performance, its power, lies at the boundary of our present language, in what cannot yet be spoken. Approaching performance art in this way, as condensing past and present into an explosive "now" that presages a future that cannot yet be given words, is a much more promising method than the always burdensome expectation that artists preserve or transmit their culture against the ravages of time and the dilutions of cross-cultural contact. Even better, it gives performance exciting new vocations within the political field, ones for which more collaborations and experiments are urgently needed.